I'm blessed with so many supportive people in my life.
Here are a few:

Mom

Angie Buchanan

Janeen Kilgore

Jessica Curry Jobes

Kay Pirello Morgan

Chris Holmes

Michelle Greene

Pamela Hodges

Zeb and Tiffany Acuff

Gail Gunderson

Tina Collins

Ronei Harden

Introduction

I'm just an ordinary guy with a dream and a little bit of hope. But a little bit of hope can grow into something...sometimes.

Just a short time ago, I saw a need for adult coloring books that appeal to many age groups, but especially older generations, that were not so complex and frustrating, like many of the current adult coloring books. I decided to act quickly, creating three coloring books as a start to fill the gap, and I'm quickly creating more titles! This is my eighth book, and I believe it the best one yet.

I am working hard to create books that encourage, inspire hope, and evoke pleasant, nostalgic memories that older generations, and even stroke patients can use to keep their minds active, engaged, entertained...and spry.

I welcome your feedback on these books, and future titles.

Here's to the art of staying young!

Help others find this product by reviewing it on Amazon!

Find us:
　　Facebook: facebook.com/sprymind
　　Instagram: @mysprymind
　　Twitter: @mysprymind
　　Web: sprymind.com
　　Web: sprymind.com

Your purchase provides nursing homes, clinics and others with free books.

I've become a big fan of fountain pens recently! They are fun to use, and after spending so much time on digital devices, it's nice to sit down and actually write and draw again with actual pen and paper.

I highly recommend the good people at The Goulet Pen Company. Find them here: http://www.gouletpens.com

Choosing Your Tools:

Keeping it old school with crayons

Good old crayons have been around forever. They are inexpensive, and come in a large selection of colors. And, if you are very lucky, you got a box with the sharpener in the back! Crayons evoke good times, childhood, timeouts, learning about color and about staying in the lines, or not. Even now, I love the smell of crayons. They evoke the best memories. By all means, color with crayons if you like.

Pros: Inexpensive, easily available, and great memories.

Cons: Crayons simply do not lay down color as well as other options, the color is not usually smooth, and they tend to be blunt, and may be difficult to control in smaller areas.

Bring out your inner artist with colored pencils

Most adults prefer to color with colored pencils. They range greatly in price, from cheap to "am I willing to eat ramen noodles for a month to buy these". Colored pencils come in boxes of various numbers of pencils.

Pros: Great color coverage, excellent control for finer detail, they can blend with other colors.

Cons: Some kinds can be expensive, and you will want to buy more and more to add to your collection.

Make Van Gogh jealous with watercolor pencils

There are special colored pencils that you use like regular colored pencils, that can then be blended with water, using a brush, a cotton swab or even your finger. Water color pencils can be great fun...and of course, they blend spectacularly well.

Pros: Intense pigments, blends and softens easily with water.

Cons: Can be expensive, but since they blend and mix well, you can get by with fewer colors.

Be bold with markers

Any kind of markers can be used to color your favorite coloring pages. Sharpies, highlighters, bold tip and fine point all can be used to color your work. The ink usually goes on quickly and is usually intense.

Pros: Bold, fun colors, many to choose from, including metallics.

Cons: Can be harder to control, can bleed through to the other side of the page, even the page behind it. But Spry Mind books leave the back page blank, to avoid damaging your artwork.

All the cool kids use gel pens

Gel pens are really fun. They lay down color that is smooth and intense, and most gel pens have a fine point that gives you excellent control. I have found that if you work quickly with gel pens and choose colors that mix well, that you can smudge and blend them before they dry. I use my finger, or a cotton swab or a tissue. Color fast, smudge to blend!

Pros: Fun colors, including metallics, excellent control in detailed areas.

Cons: Don't blend quite as well as colored pencils.

Other tools to have on hand

- cotton swabs for blending
- blending stumps (or tortillions) for even better blending control
- a watercolor brush for use with watercolor pencils or watercolor paints
- pencil sharpener (some give you a choice of tip sizes)
- Vaseline or coconut oil for even better blending, used with a blending tool
- graphite pencils can be used in some applications (I love the smooth feel and blending/shading ability from graphite)
- erasers can be found in many shapes and sizes, including some that sharpen like a pencil

Get creative!

You can color and embellish your artwork anyway you see fit. I know some people who have used various materials from makeup to even coffee and tea to add color to designs.

I encourage you to step outside of the box and let your creativity flourish!

Some products that I like:
- Prang colored pencils (excellent for the money)
- Prismacolor colored pencils (premium quality, more expensive)
- Derwent Inktense watercolor pencils (great quality, blends easily with water)
- LolliZ gel pens (inexpensive, but very good)
- Sharpie markers (moderately priced, many colors, and tip widths)

PRO TIP
Insert something behind the page you are coloring to prevent bleed-through. I use a thin nylon cutting mat that you might chop vegetables on, but many things can work. I also really like the firm surface of the mat behind the page, especially when using colored pencils. It helps achieve better pigment coverage.

Understanding Color

Some people will have an intuitive sense of color, and some will not. Do not worry, you can learn how color works, and have fun with it!

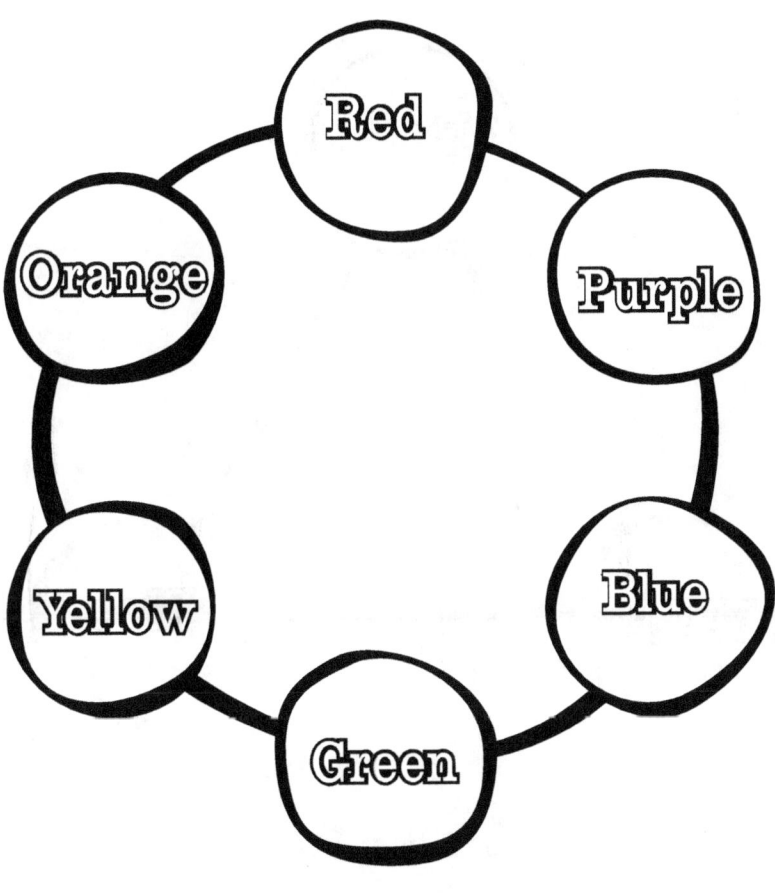

The Color Wheel

Hint: You can color these diagrams!

Primary colors
There are three primary colors, from which all other colors are created from, red, yellow and blue. Picture a triangle with one color at each corner.

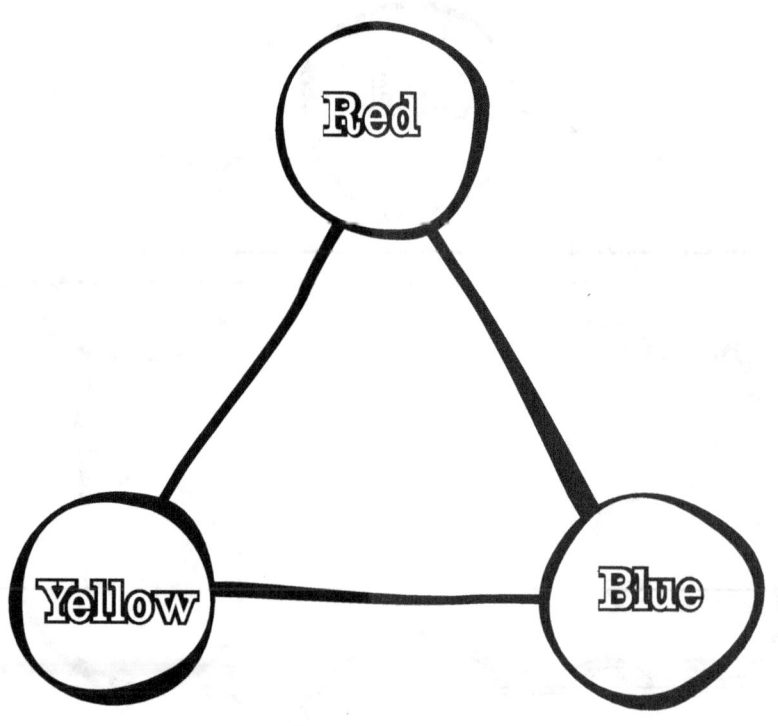

The Primary Colors

Secondary colors

There are three secondary colors, orange, green and purple. Red and yellow mix to make orange. Yellow and blue mix to make green. And, blue and red mix to make purple.
In between all of these colors are all kinds of variations!

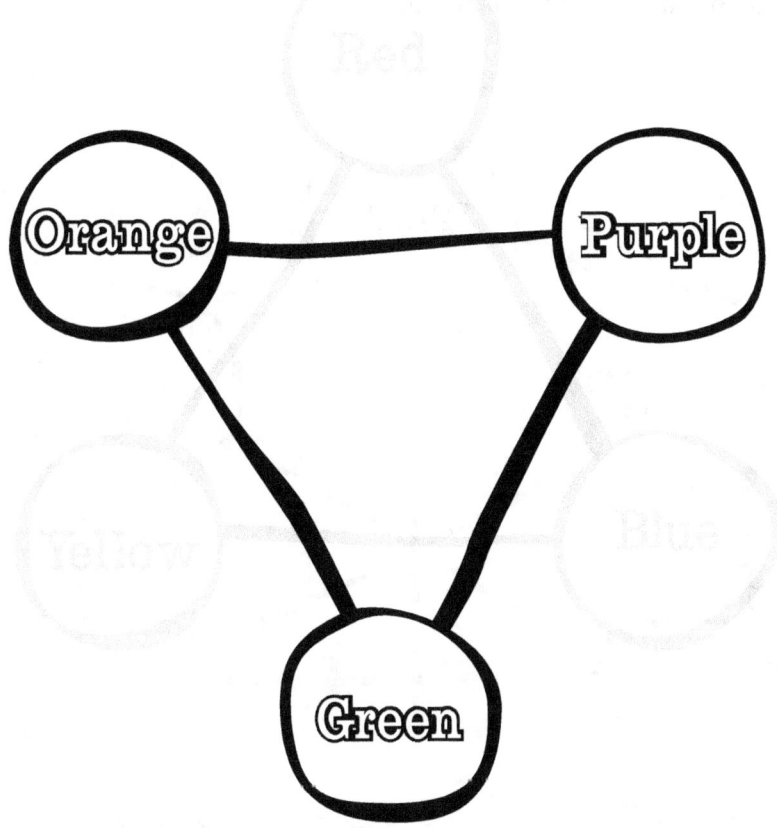

The Secondary Colors

What about black and white?

If you mix red, yellow and blue, you will get black.
White is no color at all, pure as the driven snow.

Opposite or complementary colors

Opposite colors are exactly on the other side of the color wheel. Red and green are opposites. Blue and orange are opposites. Yellow and purple are opposites. Opposite colors together create a lot of energy. They are energetic, and not harmonious. Redheads look great in green clothes! Many TV graphics rely on the blue and orange color scheme, because they command attention.

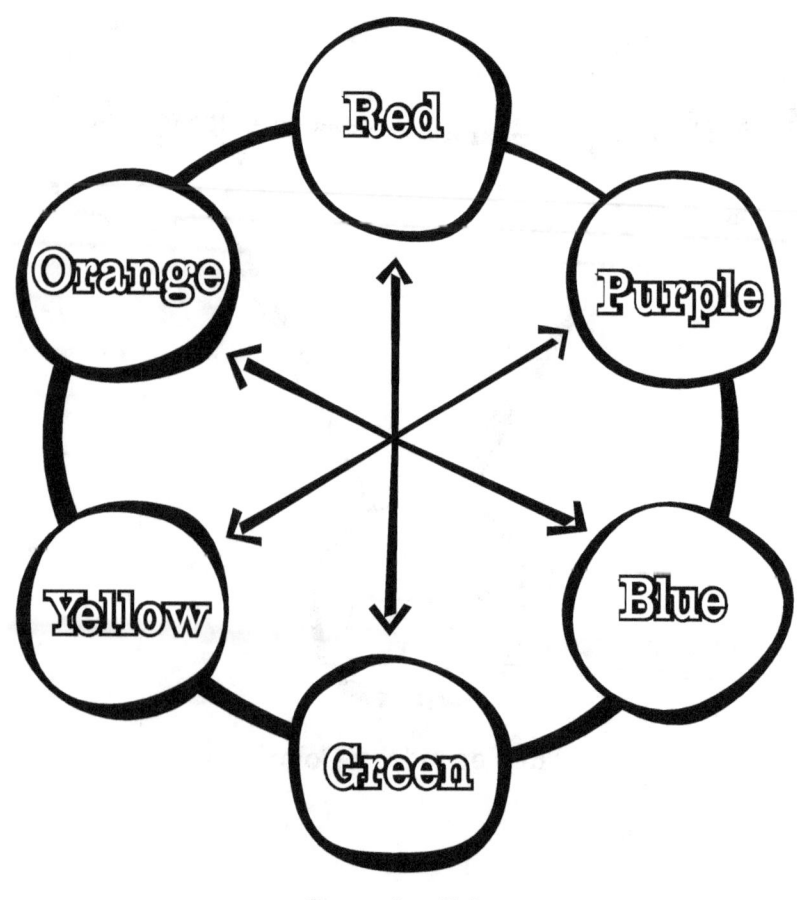

Opposite Colors

Harmonious or analogous colors

Harmonious colors are found next to each other on the color wheel. Red, orange and yellow play really well togther. Blue, green and yellow are harmonious. Red, purple, and blue are good friends. Harmonious colors are easy on the eye and much more relaxing than opposite color combinations.

Pick any color, and include the two colors on either side for color harmony.

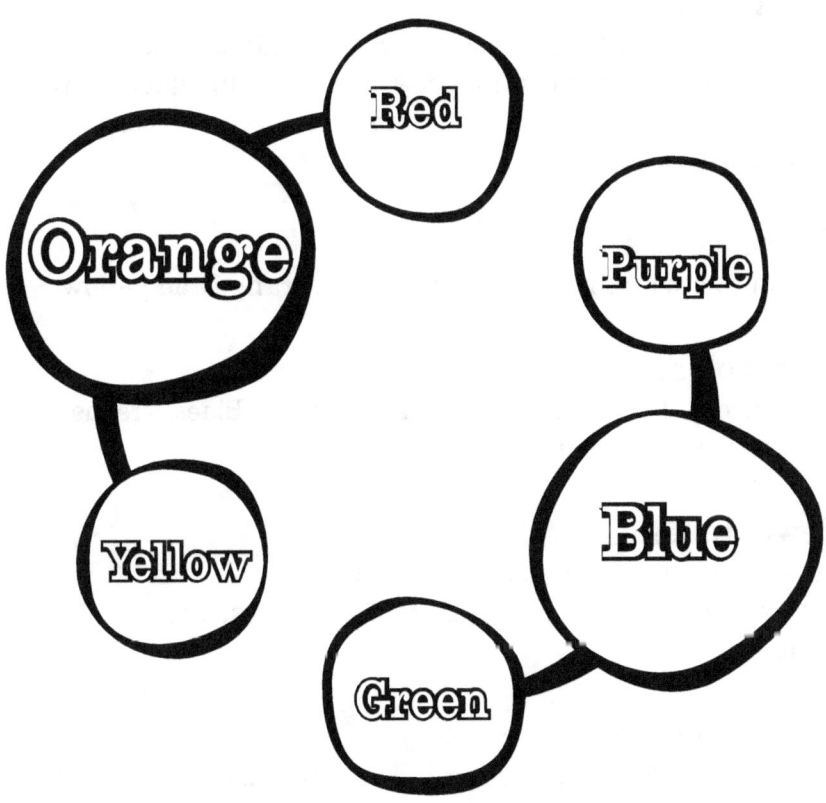

Harmonious Colors

Bright colors
Bright would describe colors that do not have black or white mixed with them. Fire engine red. Lemon yellow. Blue, like Frank Sinatra's eyes.

Pastel colors
Pastels are bright colors mixed with white. They are soft, gentle and muted. Typical Easter colors are on the pastel end of the spectrum.

Dark colors
Dark colors have black mixed with them. Dark colors are rich and soothing. Burgundy is red mixed with black. Forest green is a bright green mixed with black. Brown is orange mixed with black.

Warm colors
Warm colors remind you of a fire. Red, orange and yellow.

Cool colors
Cool colors elicit thoughts of winter and ice. Blues, greens, and purples are cool colors.

Jewel tones
Jewel tones are deep, rich colors that evoke thoughts of precious stones like rubies, emeralds, amethyst, topaz and sapphire.

Earth tones
Earth tones remind you of Fall. Tans, browns, yellows, muted greens and oranges.

Steal from the best

A great way to learn about color is to study from the best! Find artwork that you like and use that as a color guide. Use colors that are only found in the artwork you chose as your guide. Search for famous artwork or any photograph that has colors you like. Then limit your colors to those found in the guide image. This will help improve your artwork more than you can imagine. Most people try to include every color possible, and while that can certainly be fun, limiting your colors can provide a level of harmony and sophistication that will surprise you. There are no rules, but learning from the pros can teach you many things.

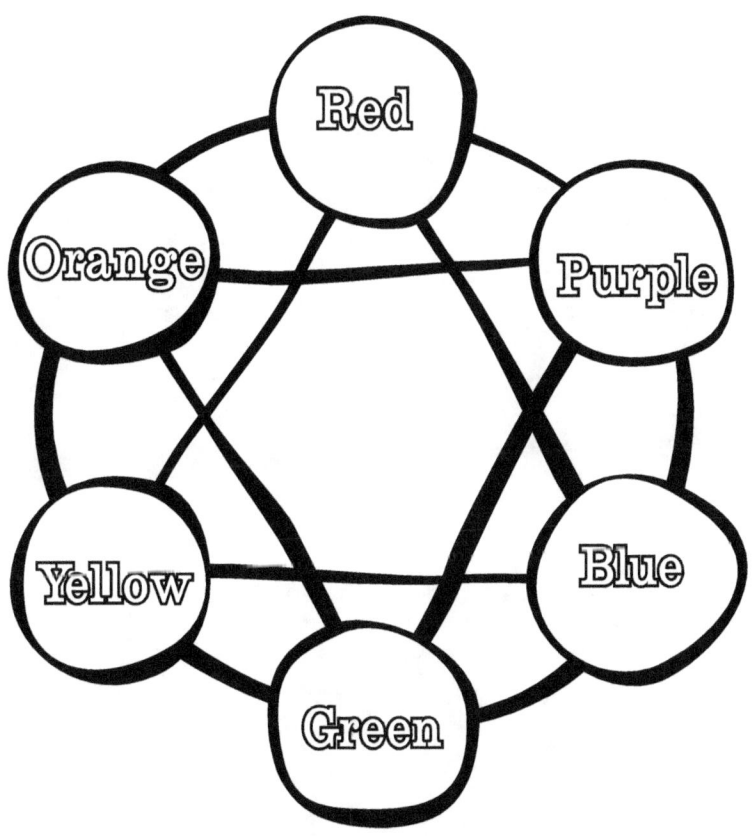

The Color Wheel

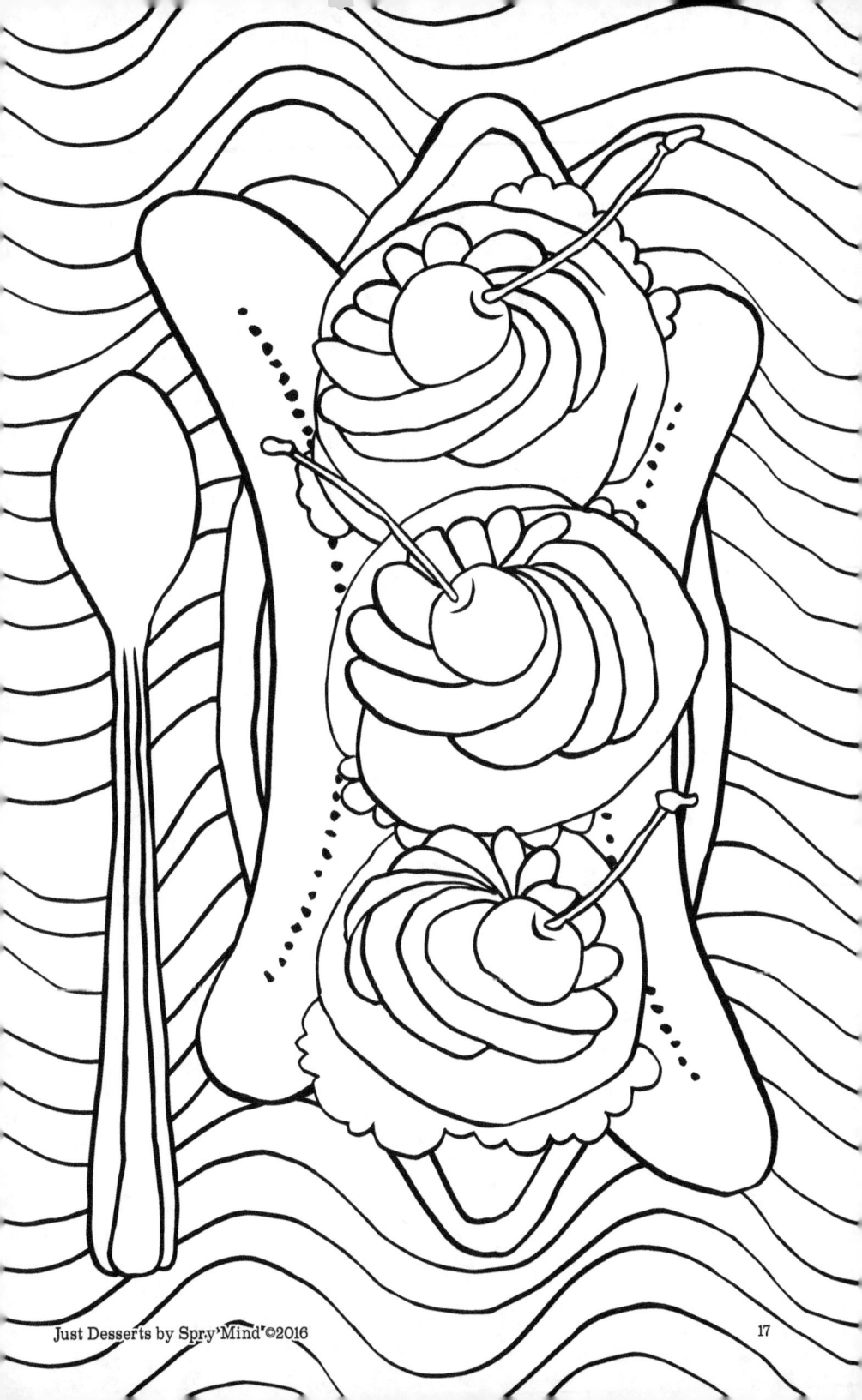

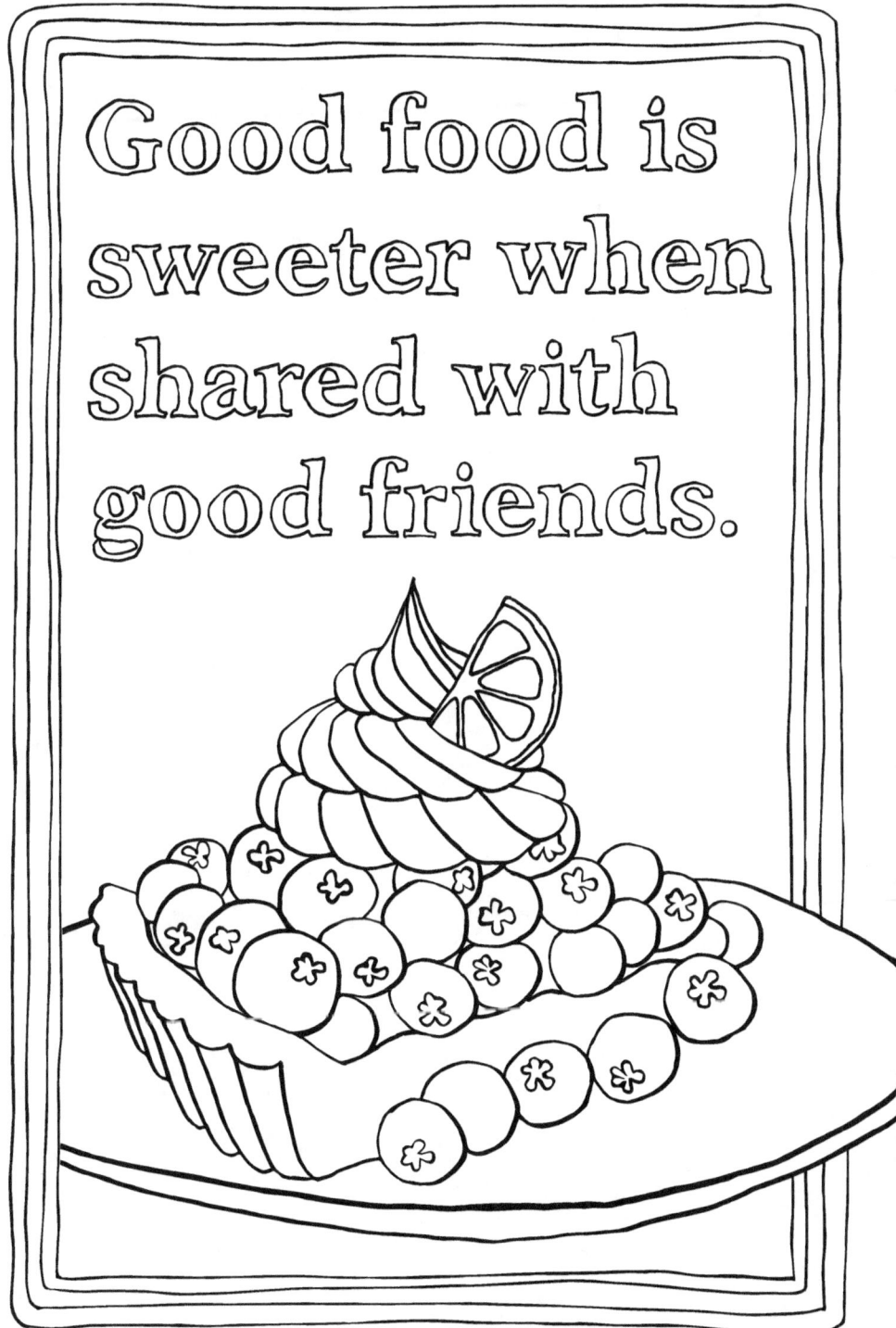

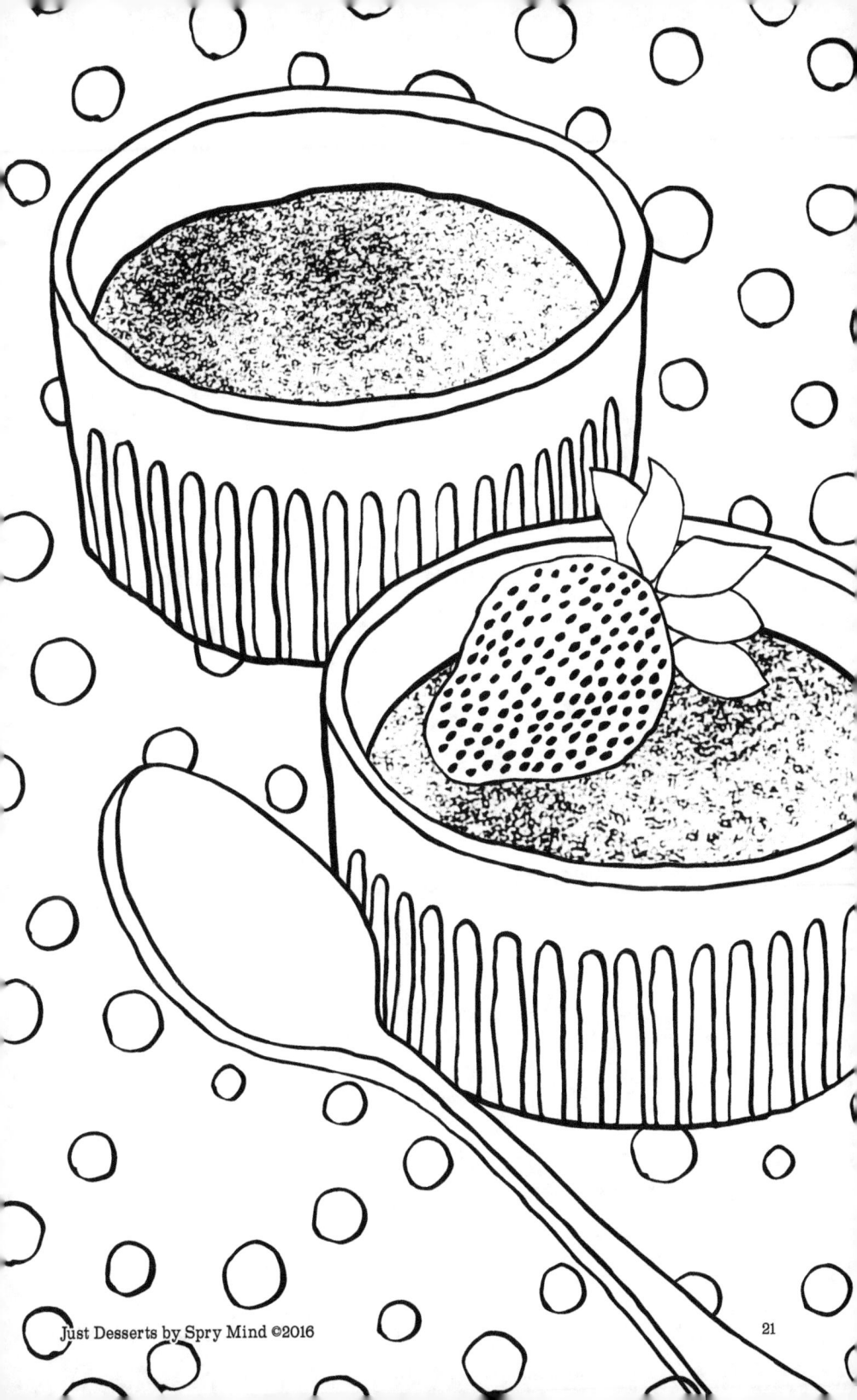

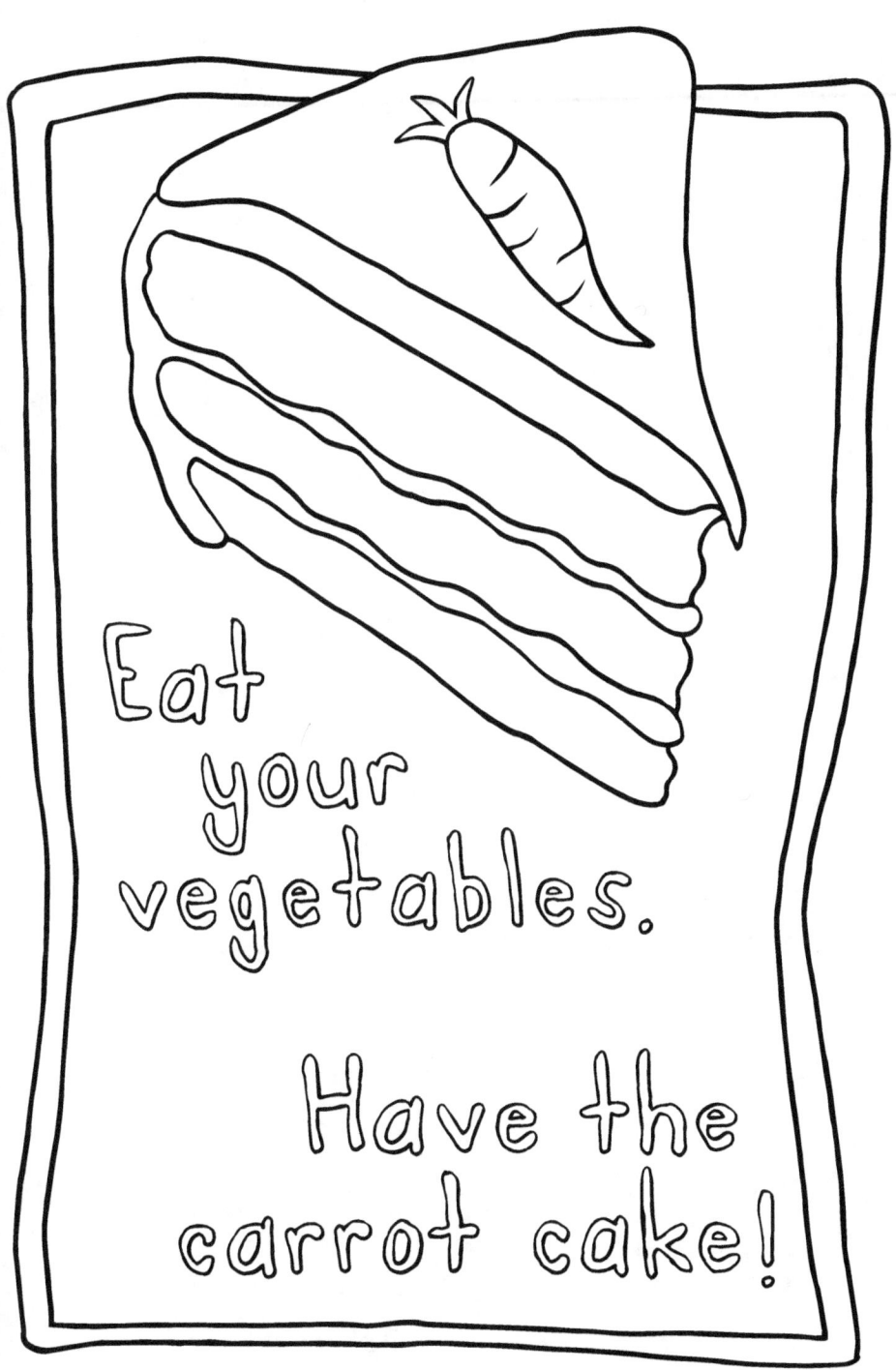

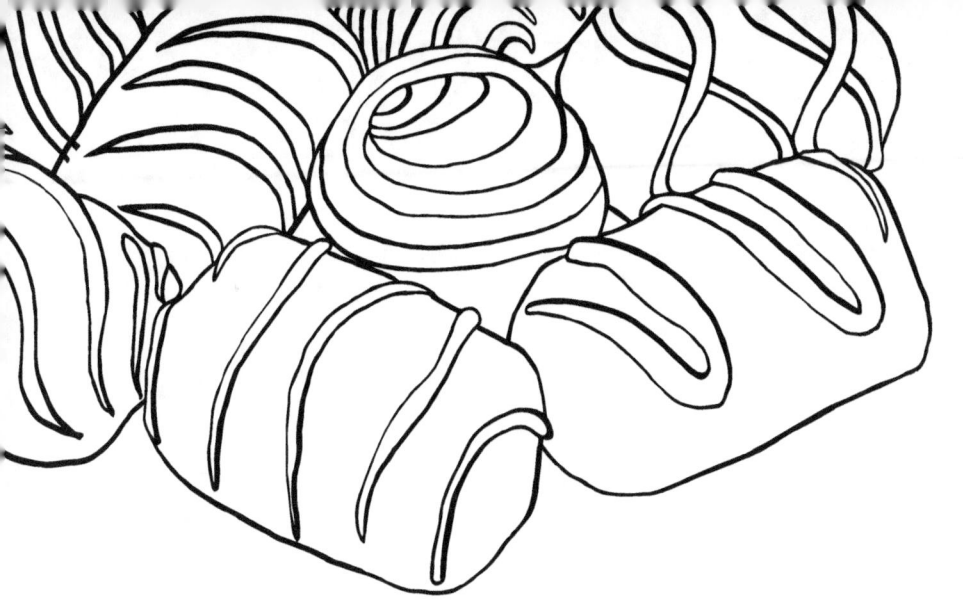

Never underestimate the POWER of chocolate.

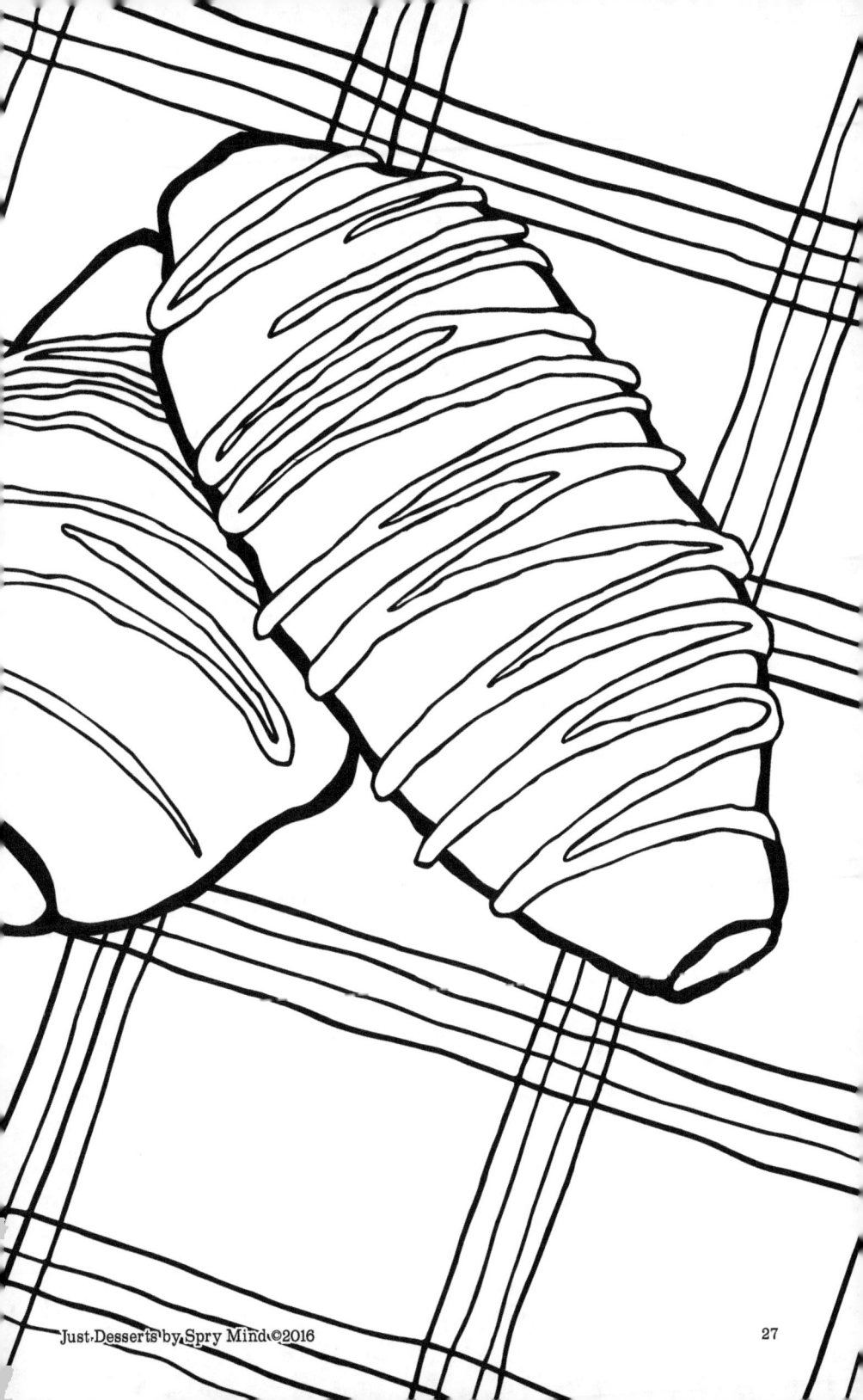

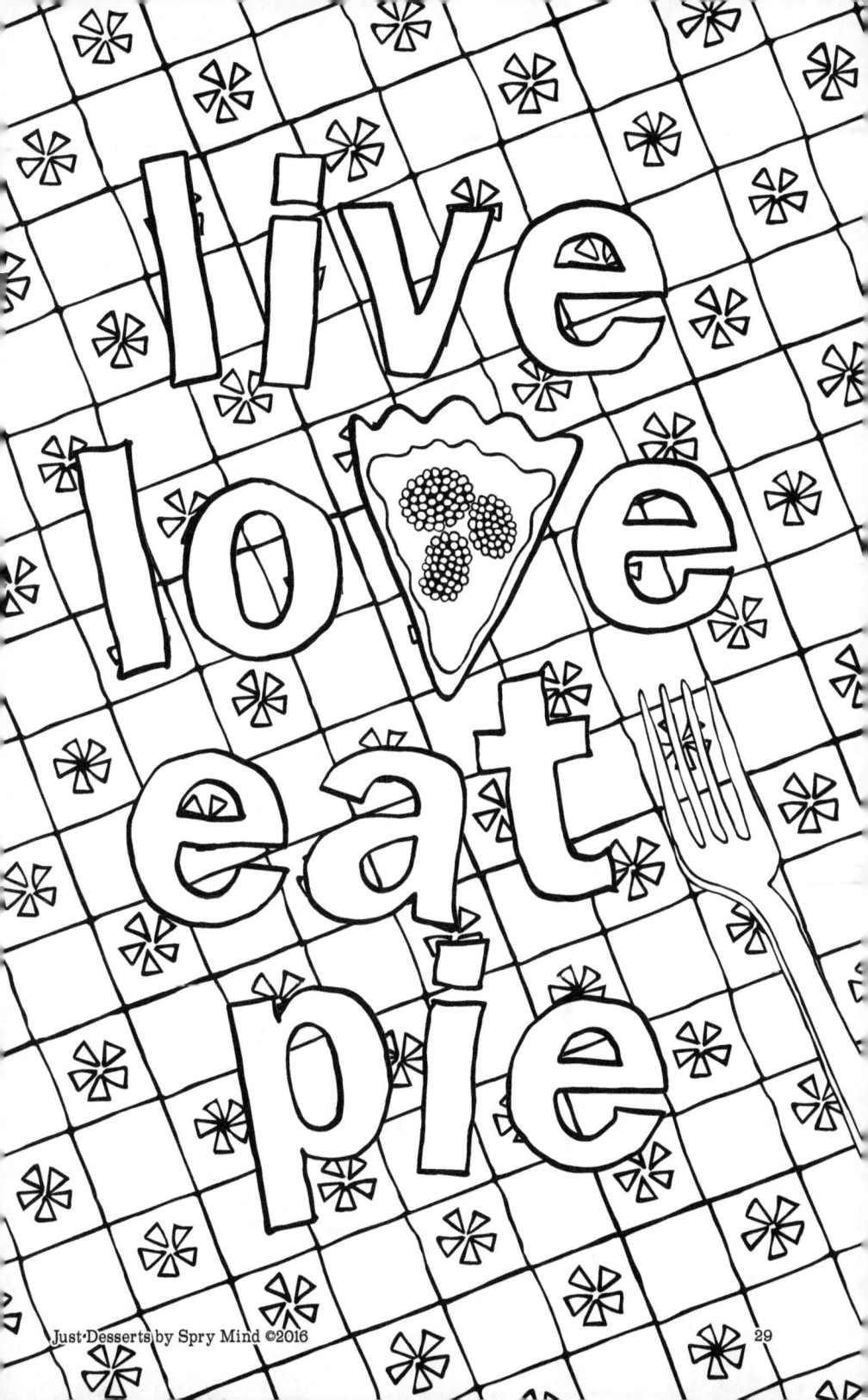

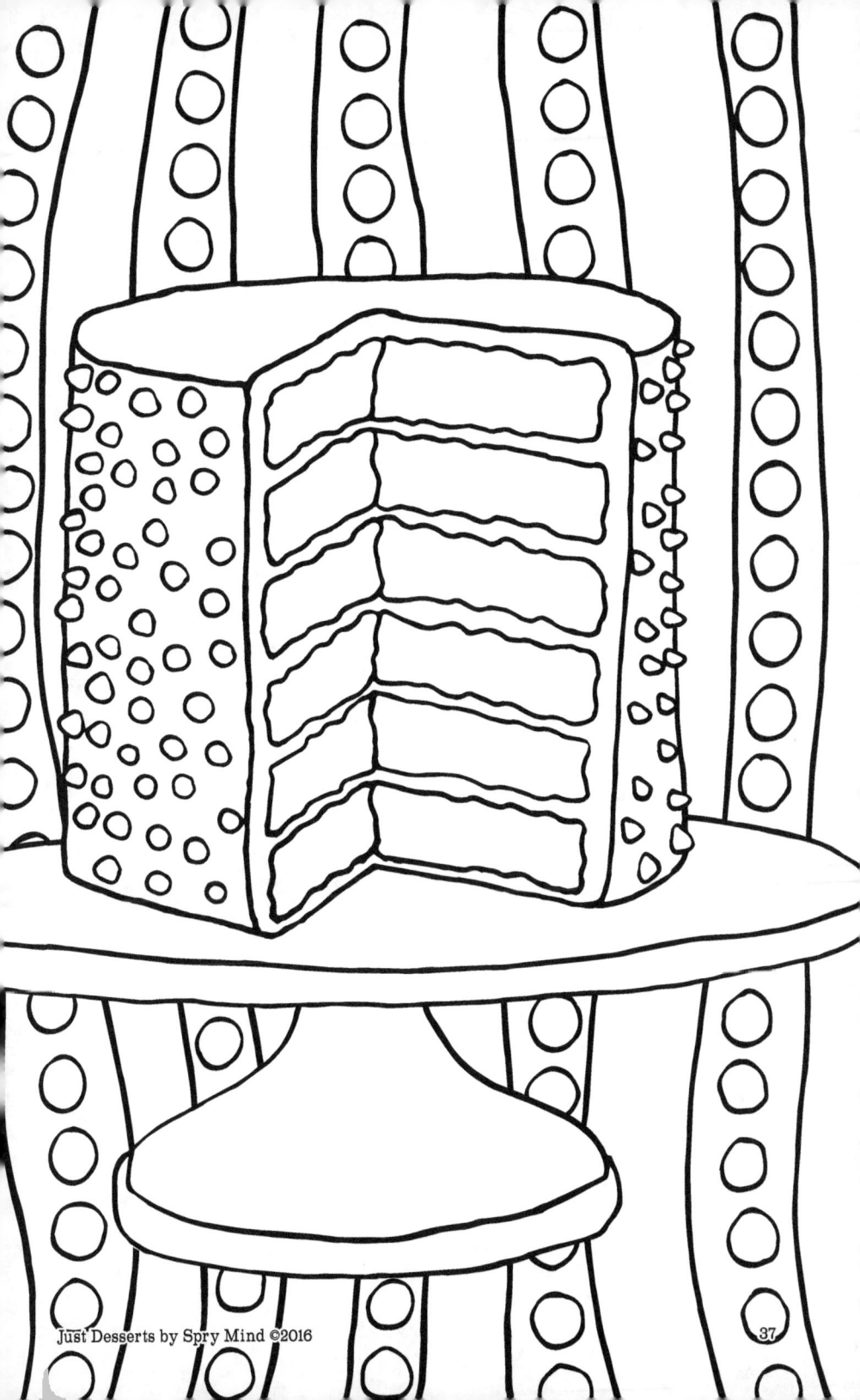

Chocolate doesn't ask questions, chocolate understands.

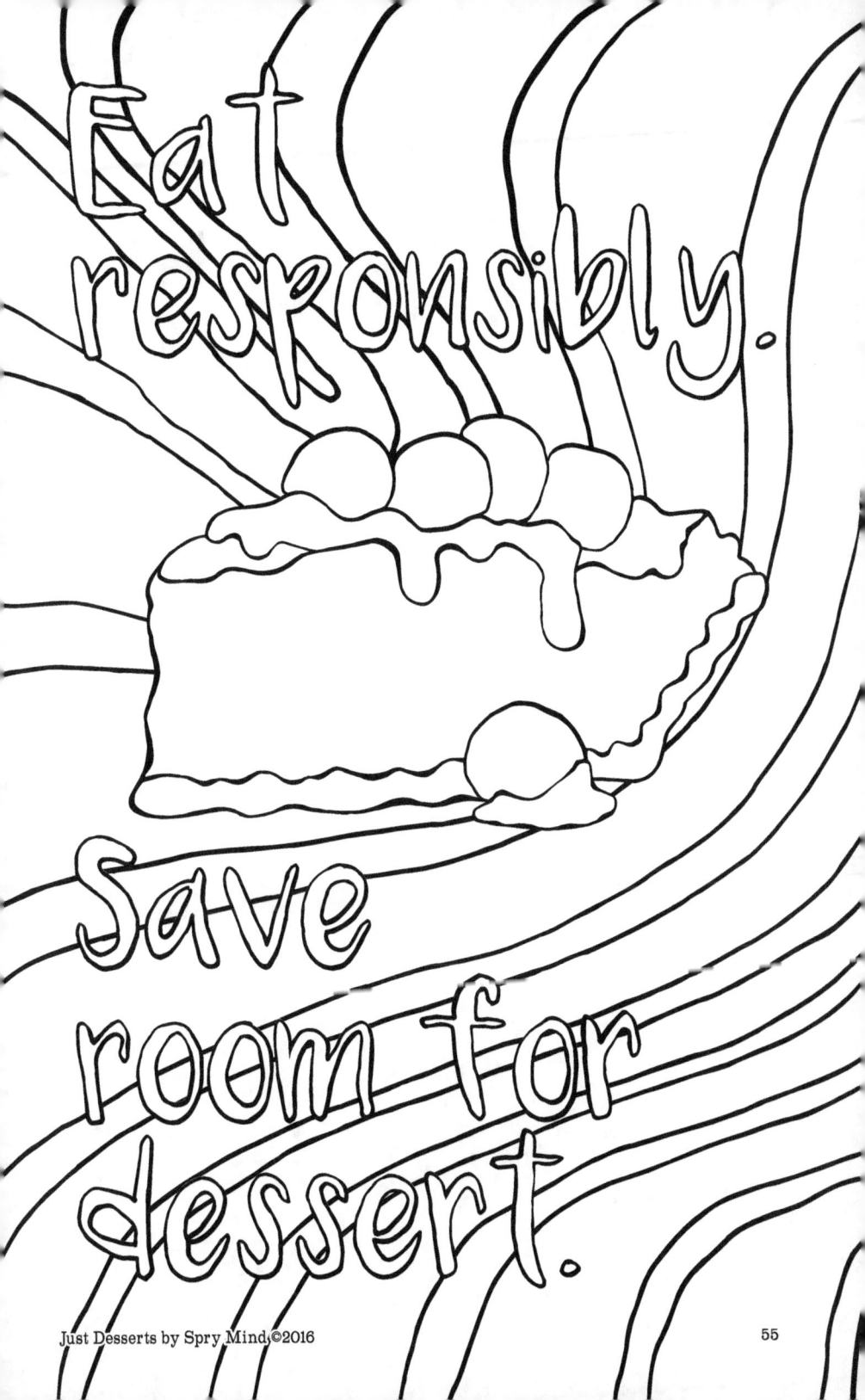

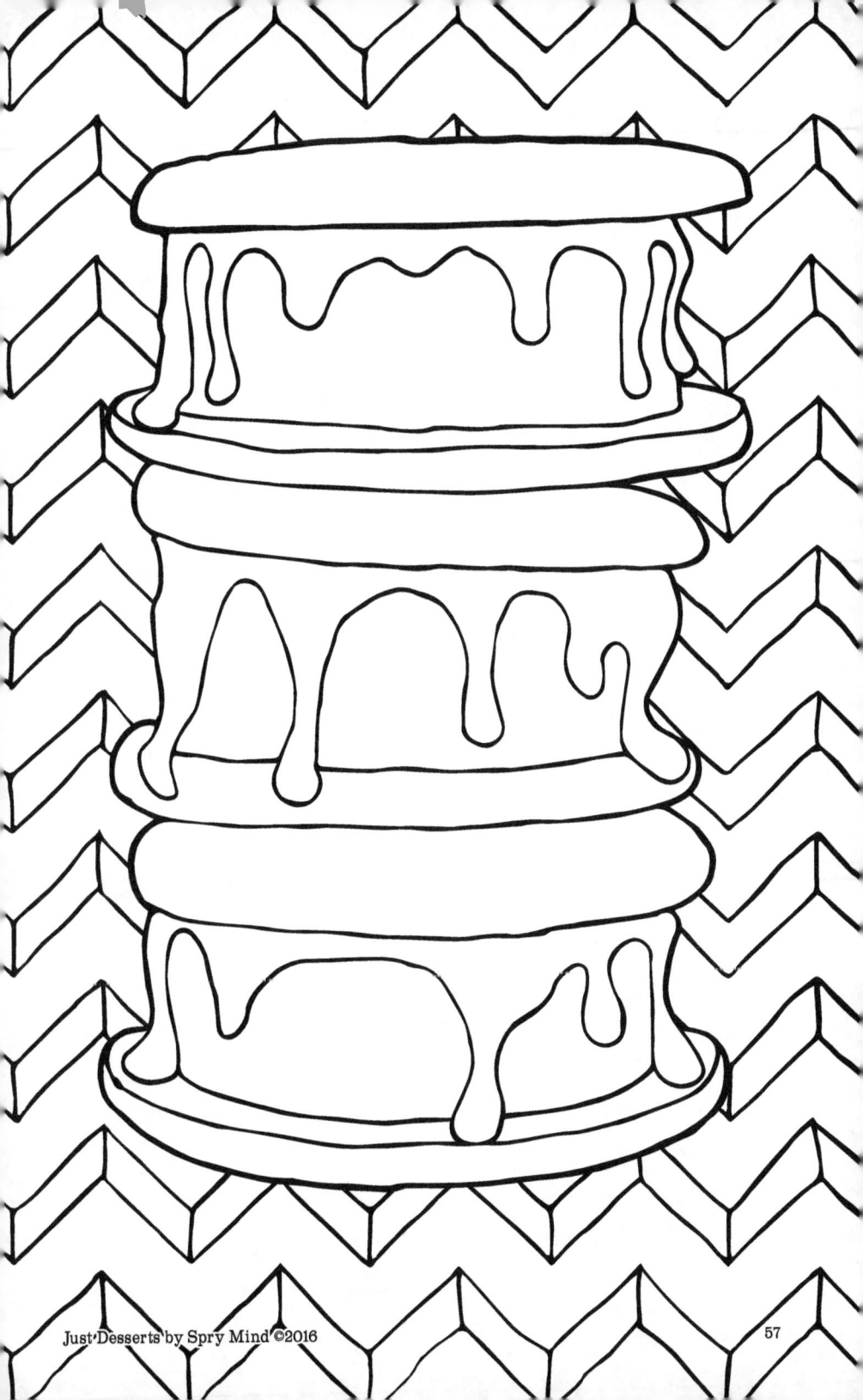

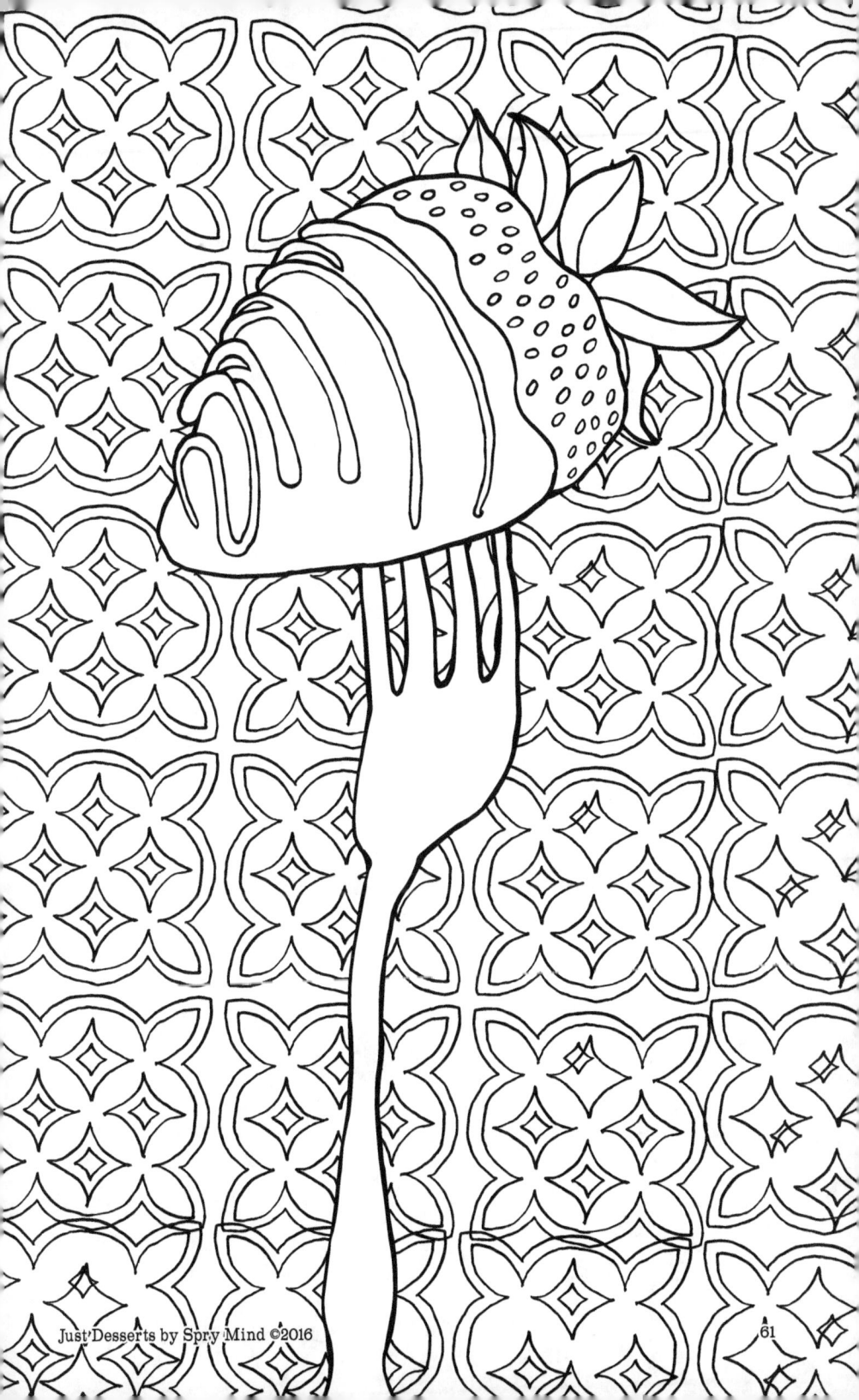

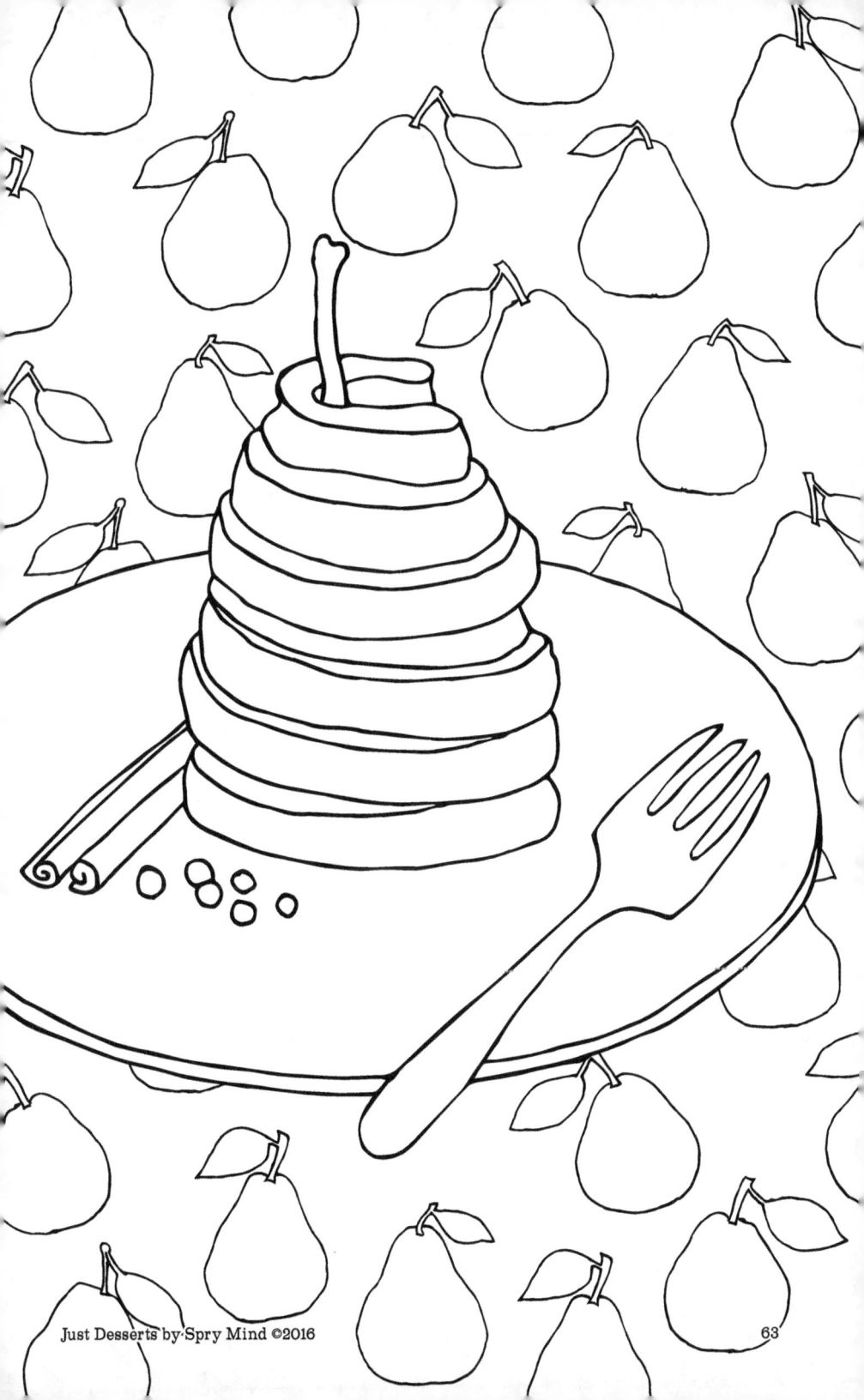

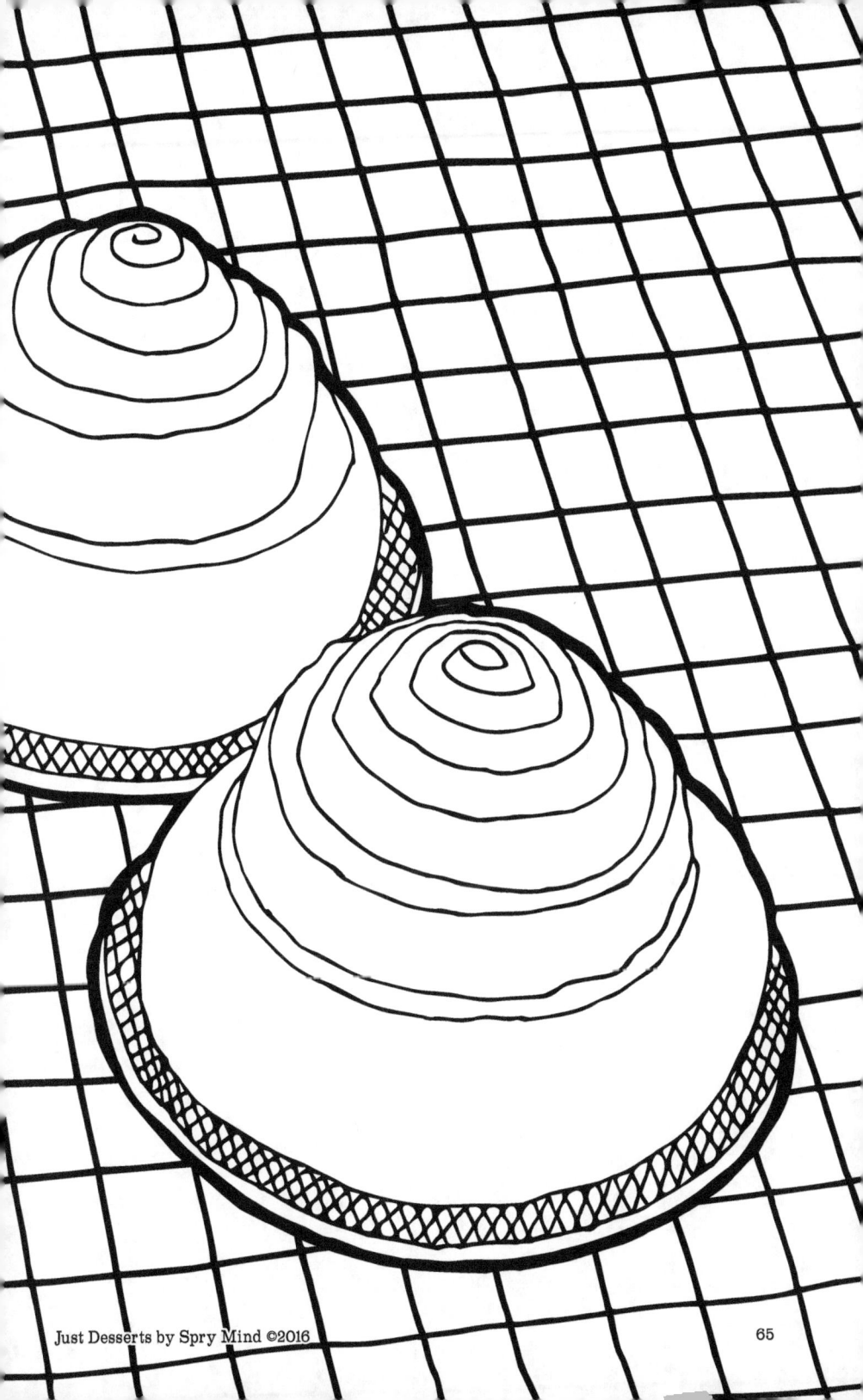

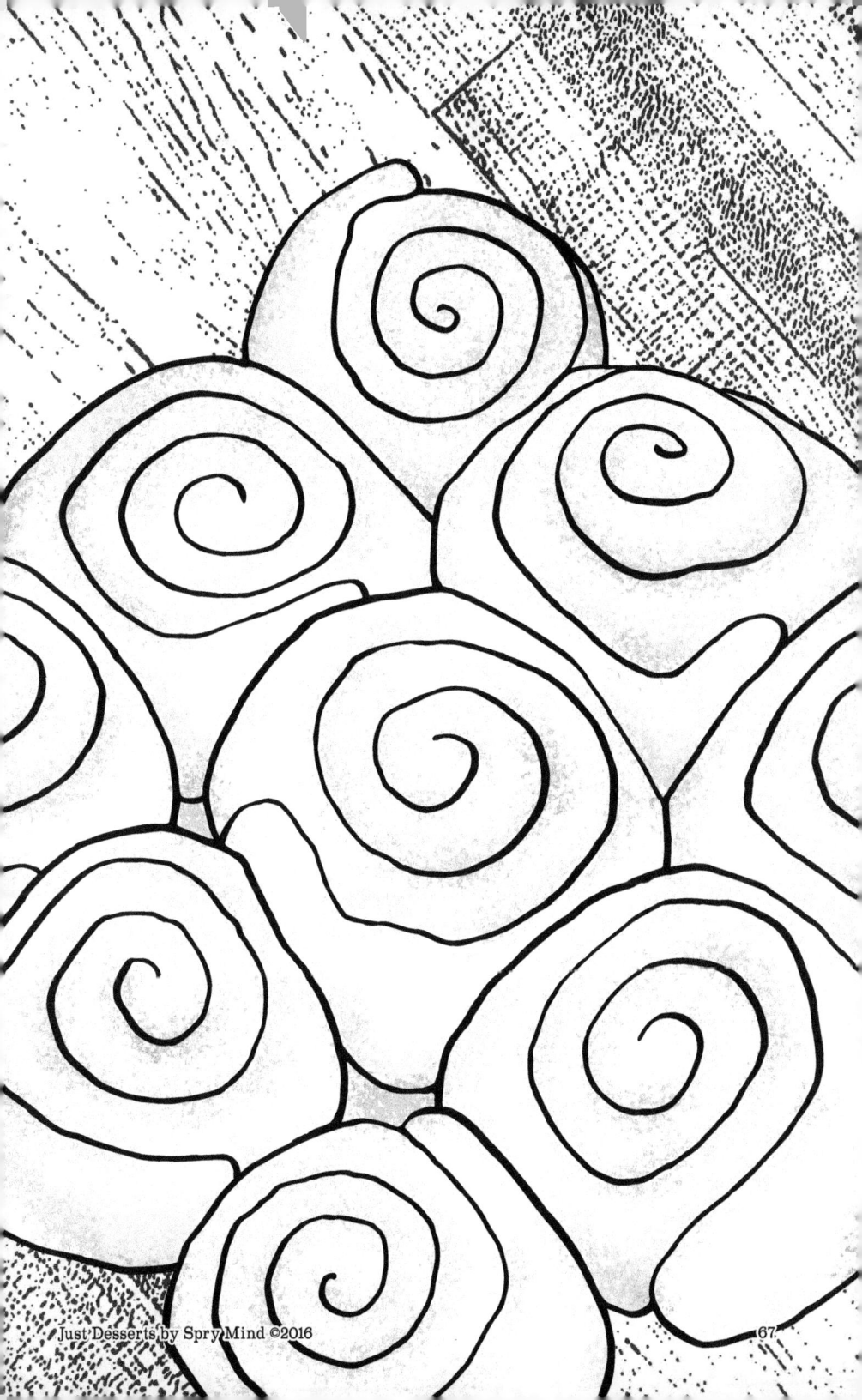

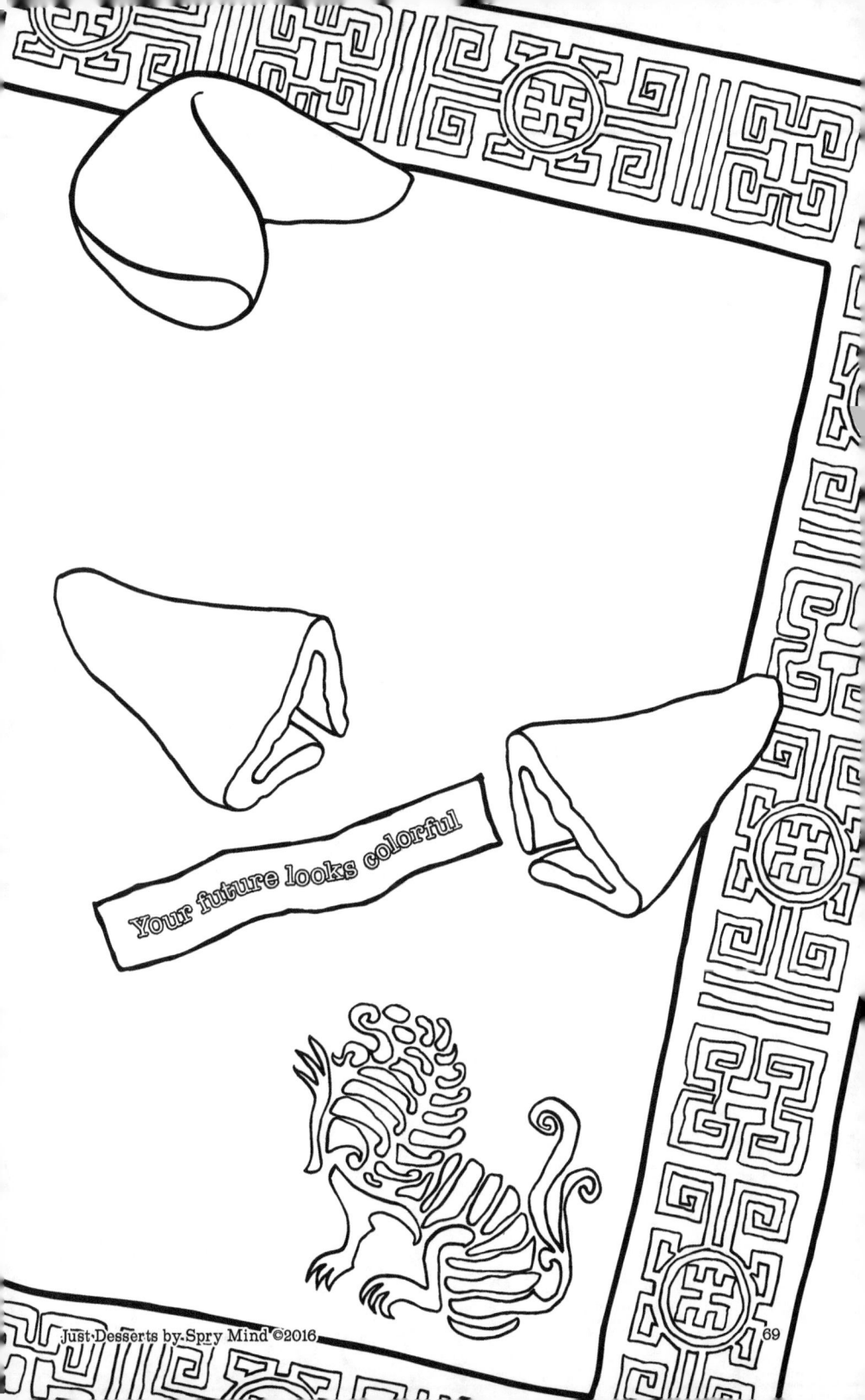

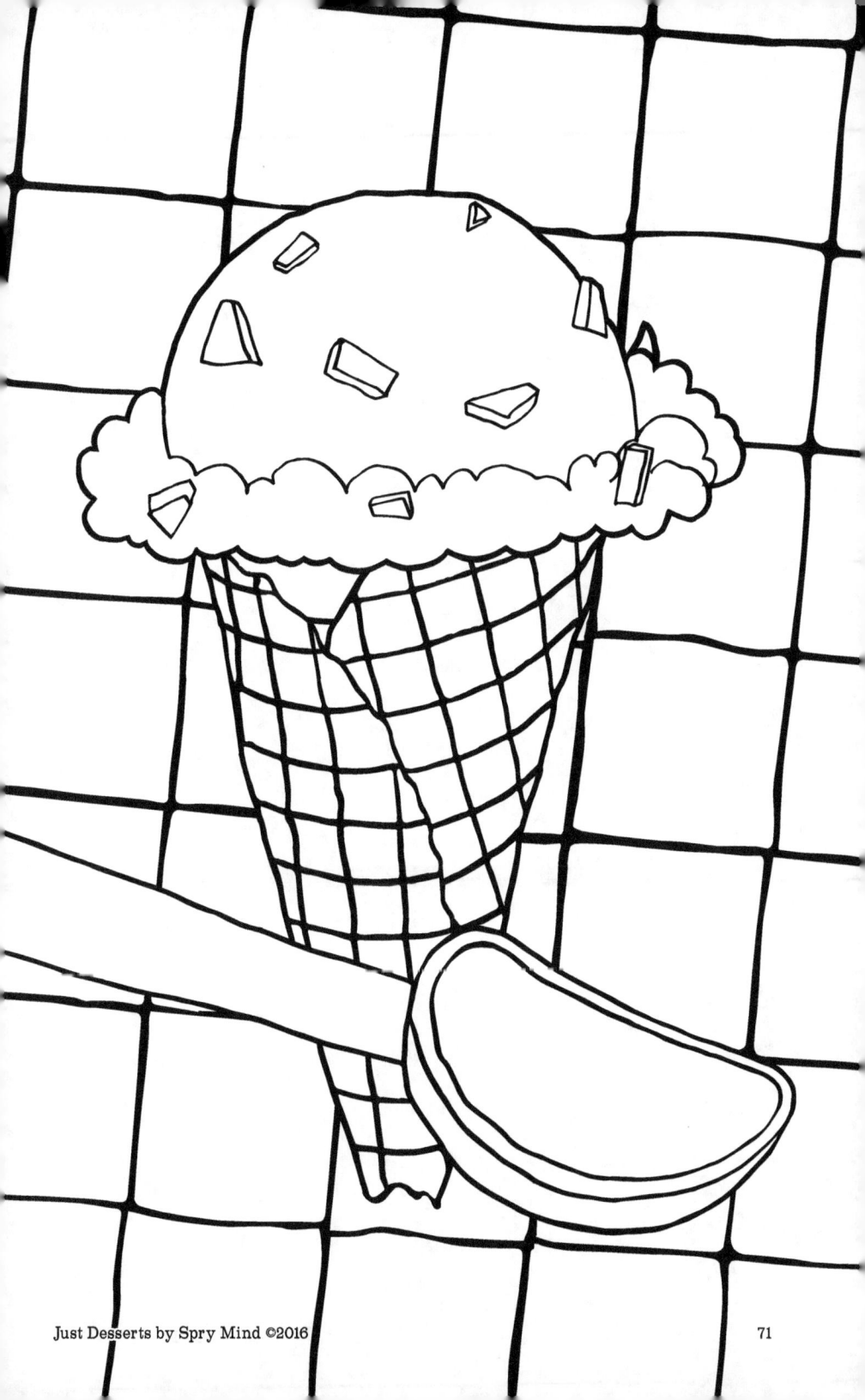

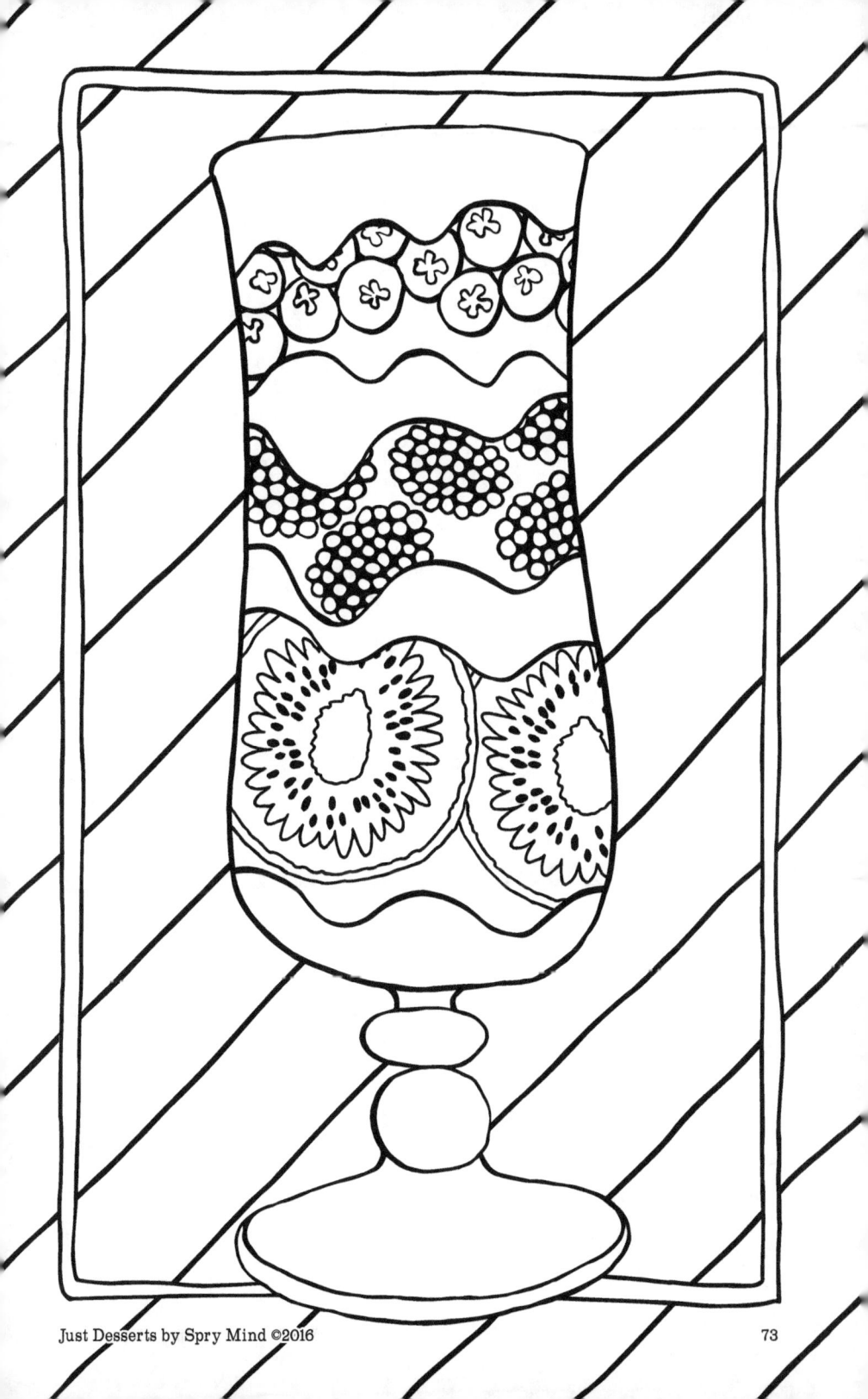

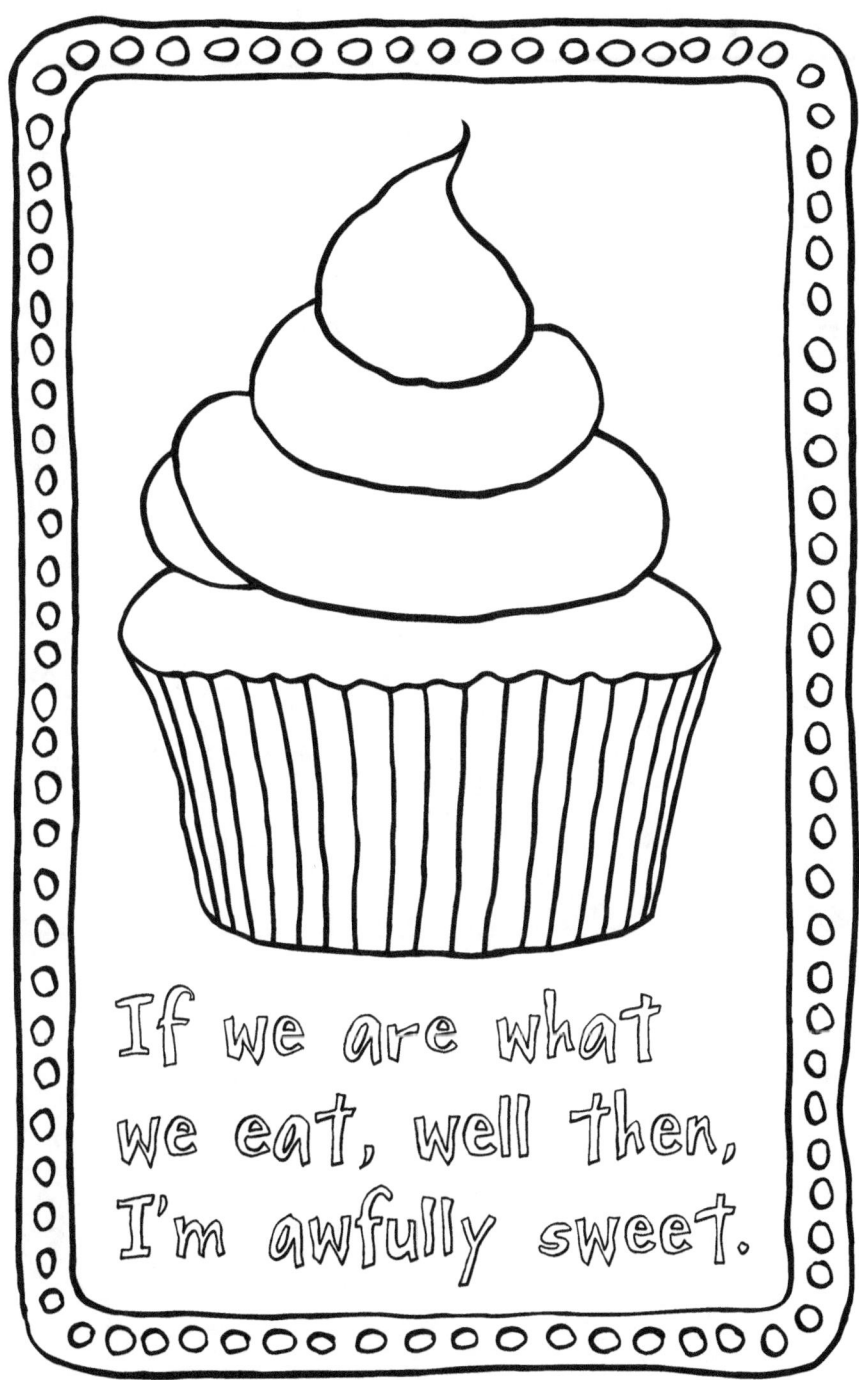

Good things happen to those who wait.

It's called dessert.

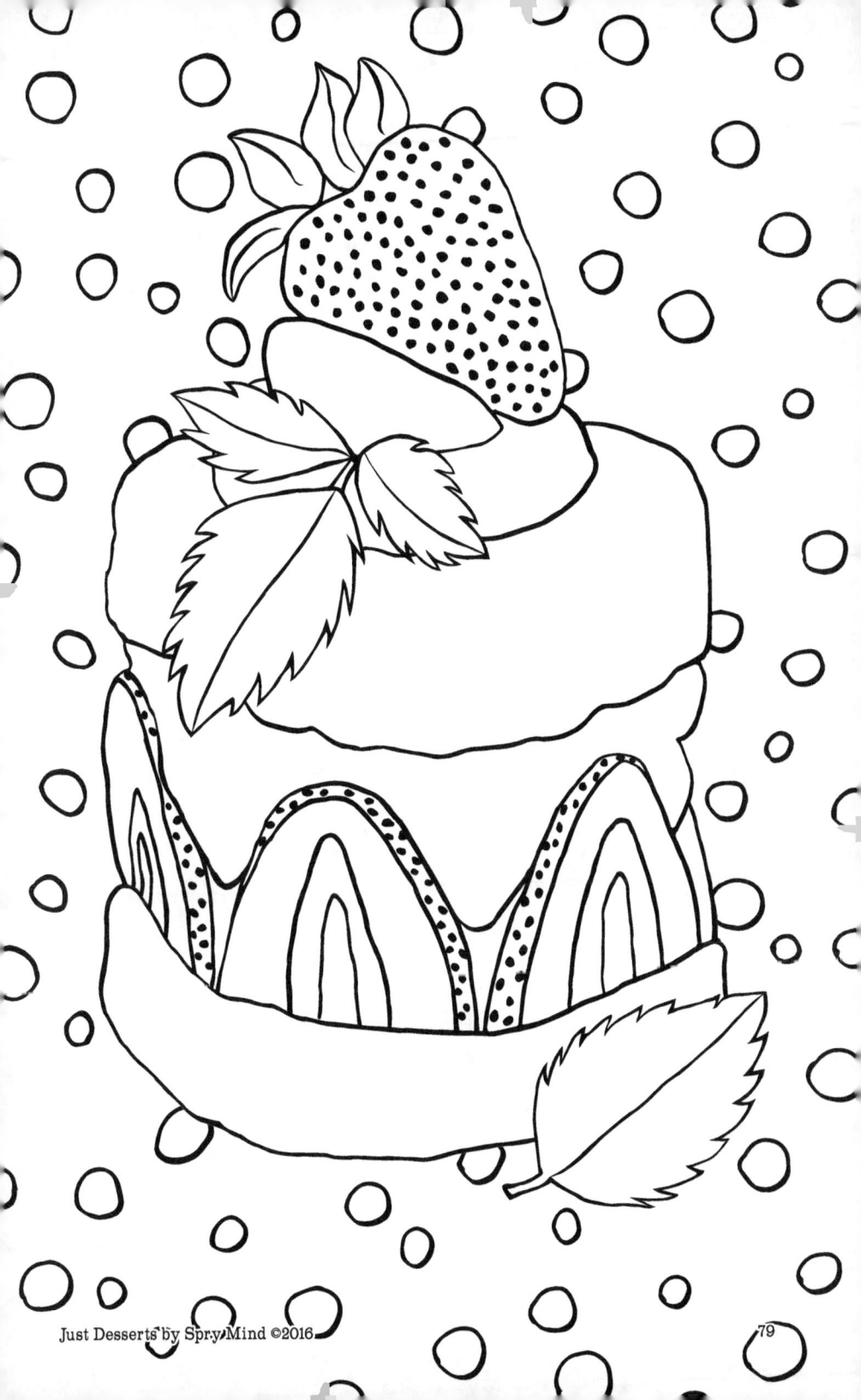

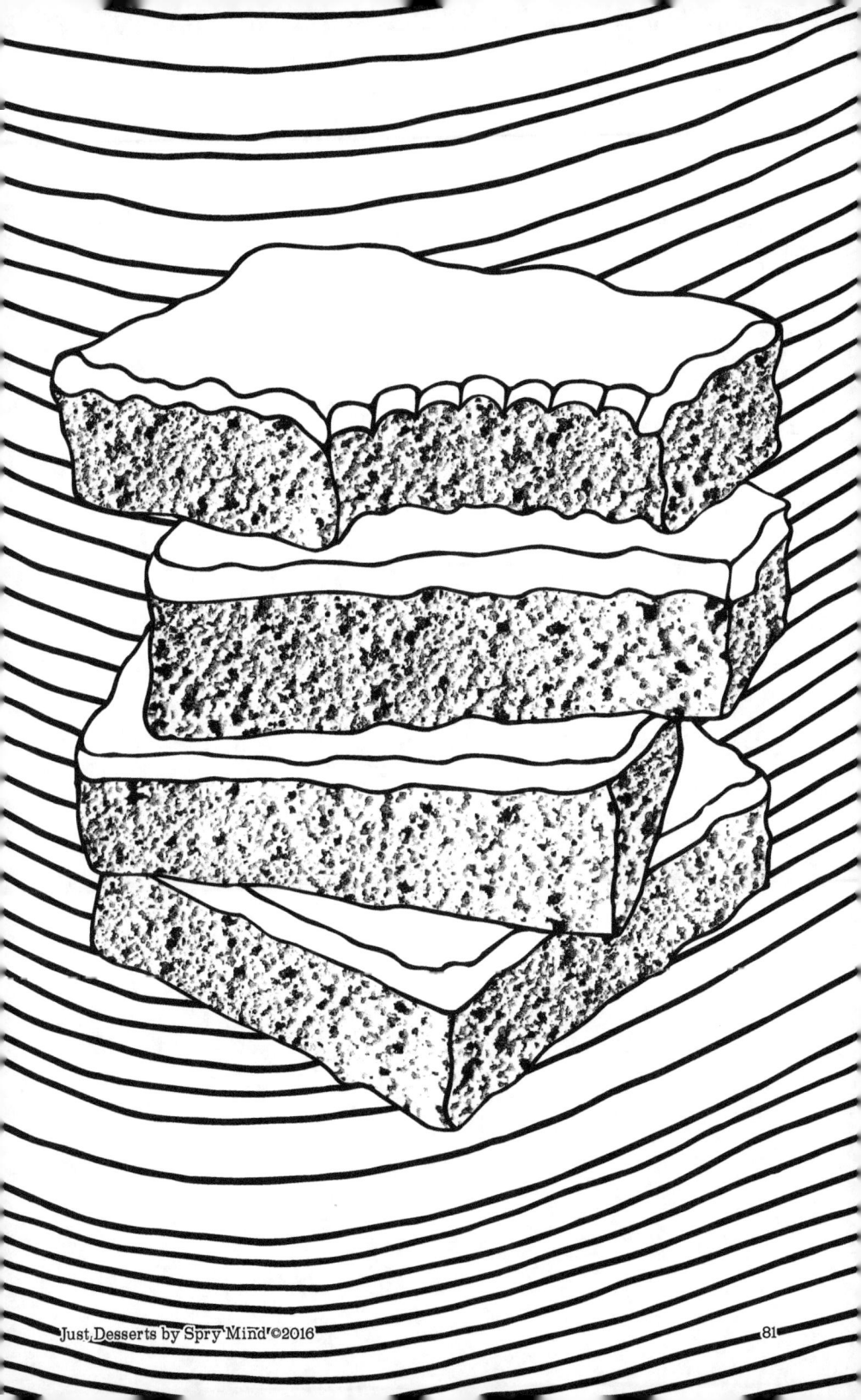

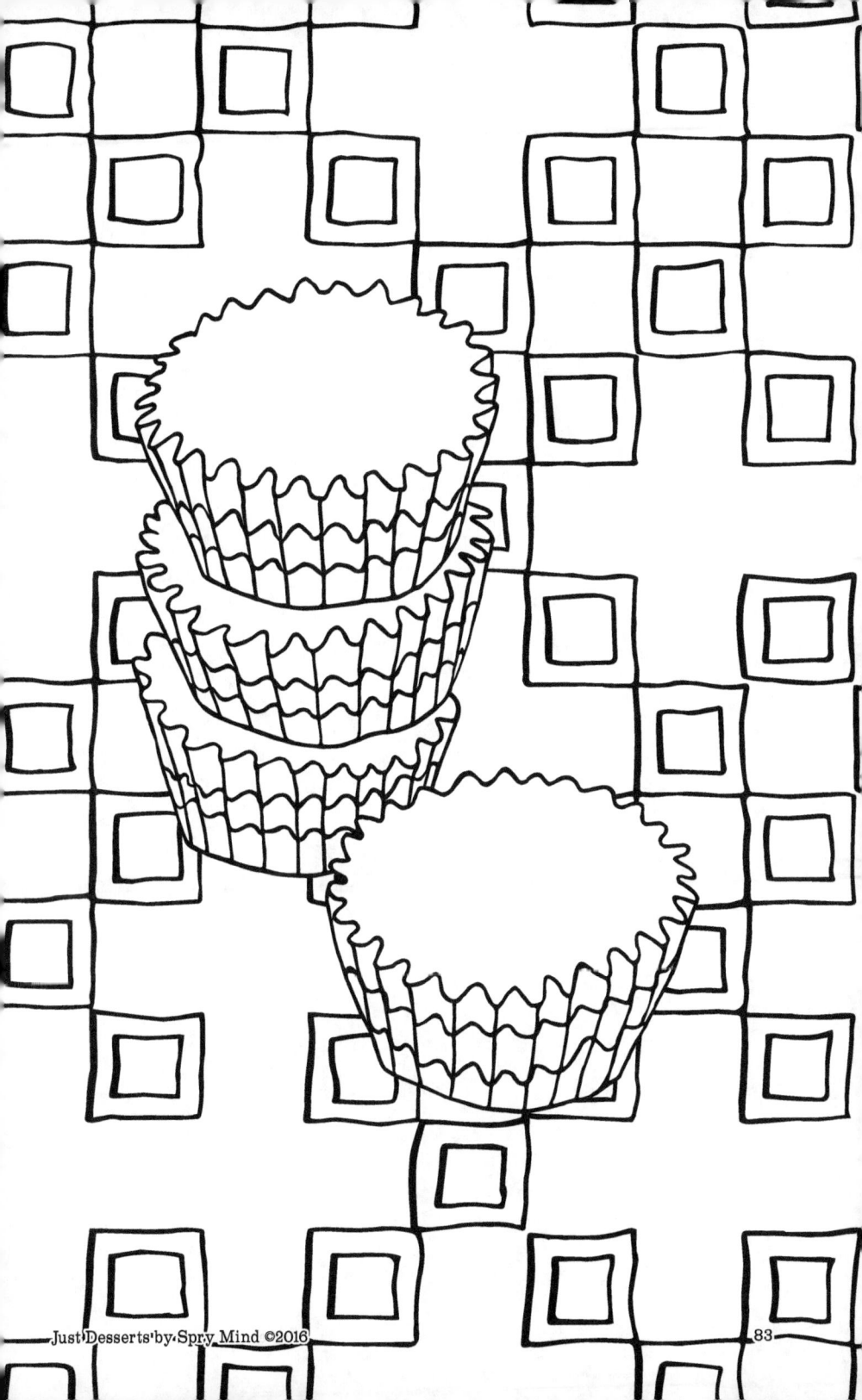

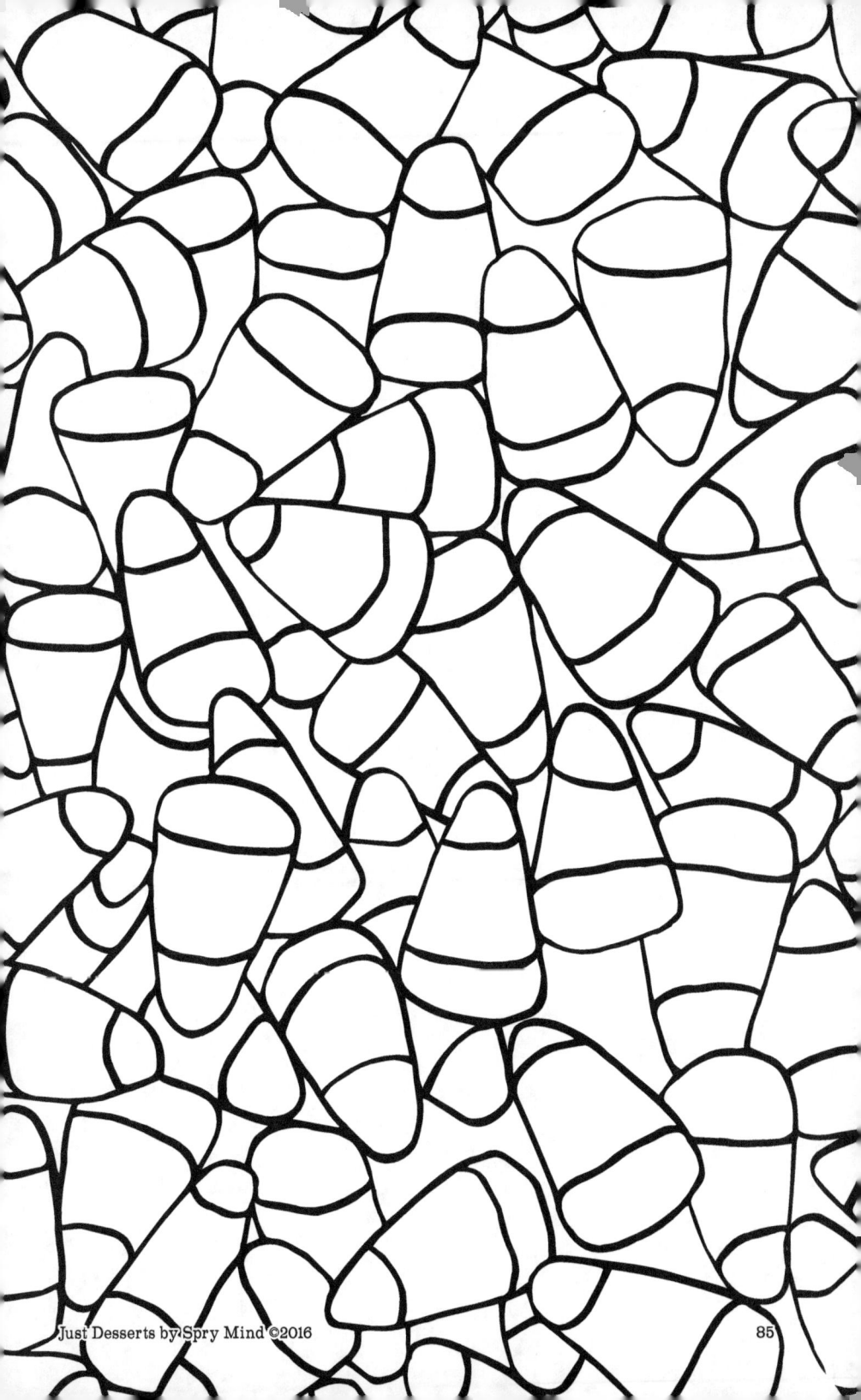

Here are some bonus pages from Coffee & Coloring!

My book "Coffee & Coloring" contains a large assortment of creative and sometimes funny designs on the theme of coffee. Images range from old fashioned coffee makers to modern coffee methods, and lots of fun in-between.

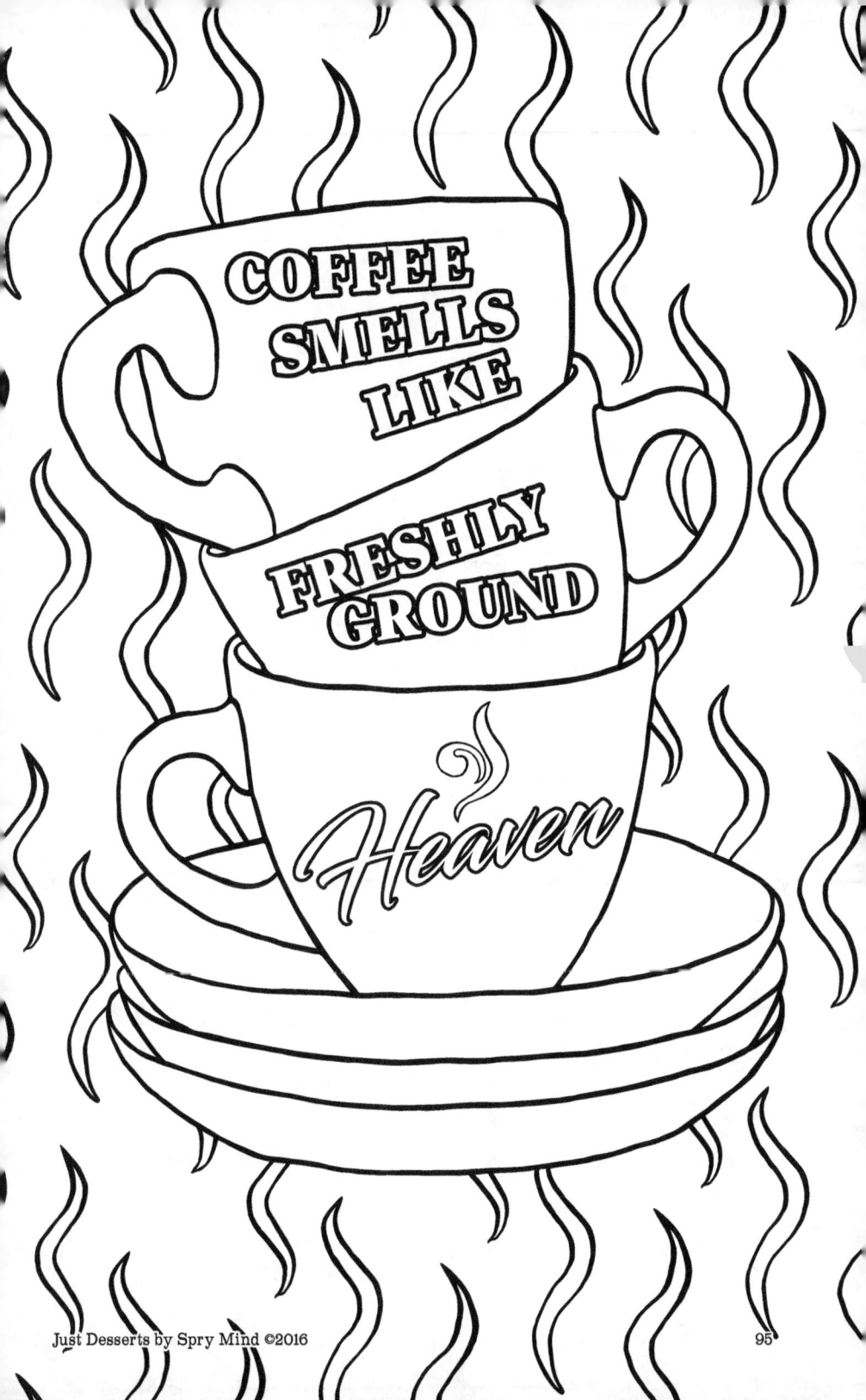

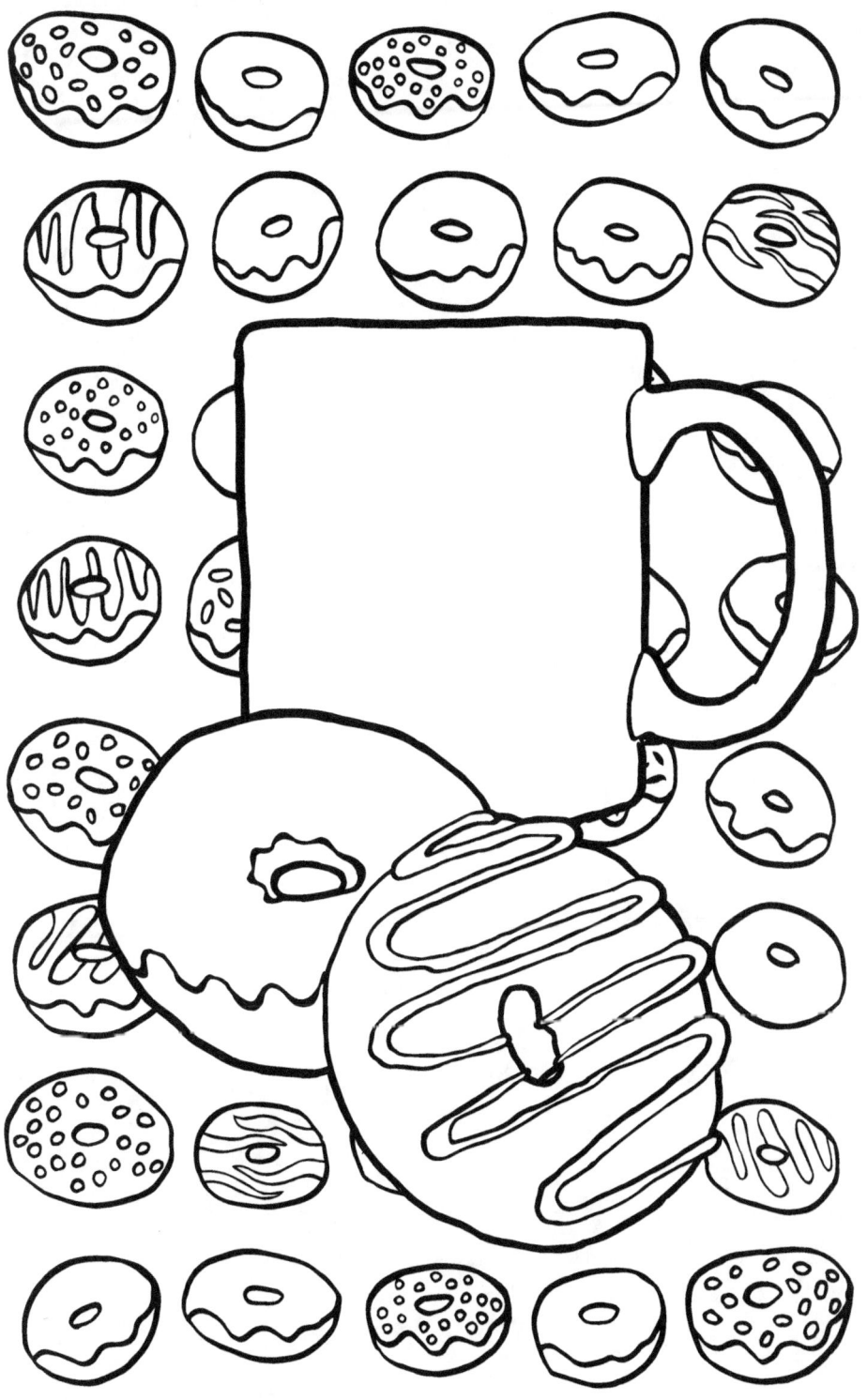

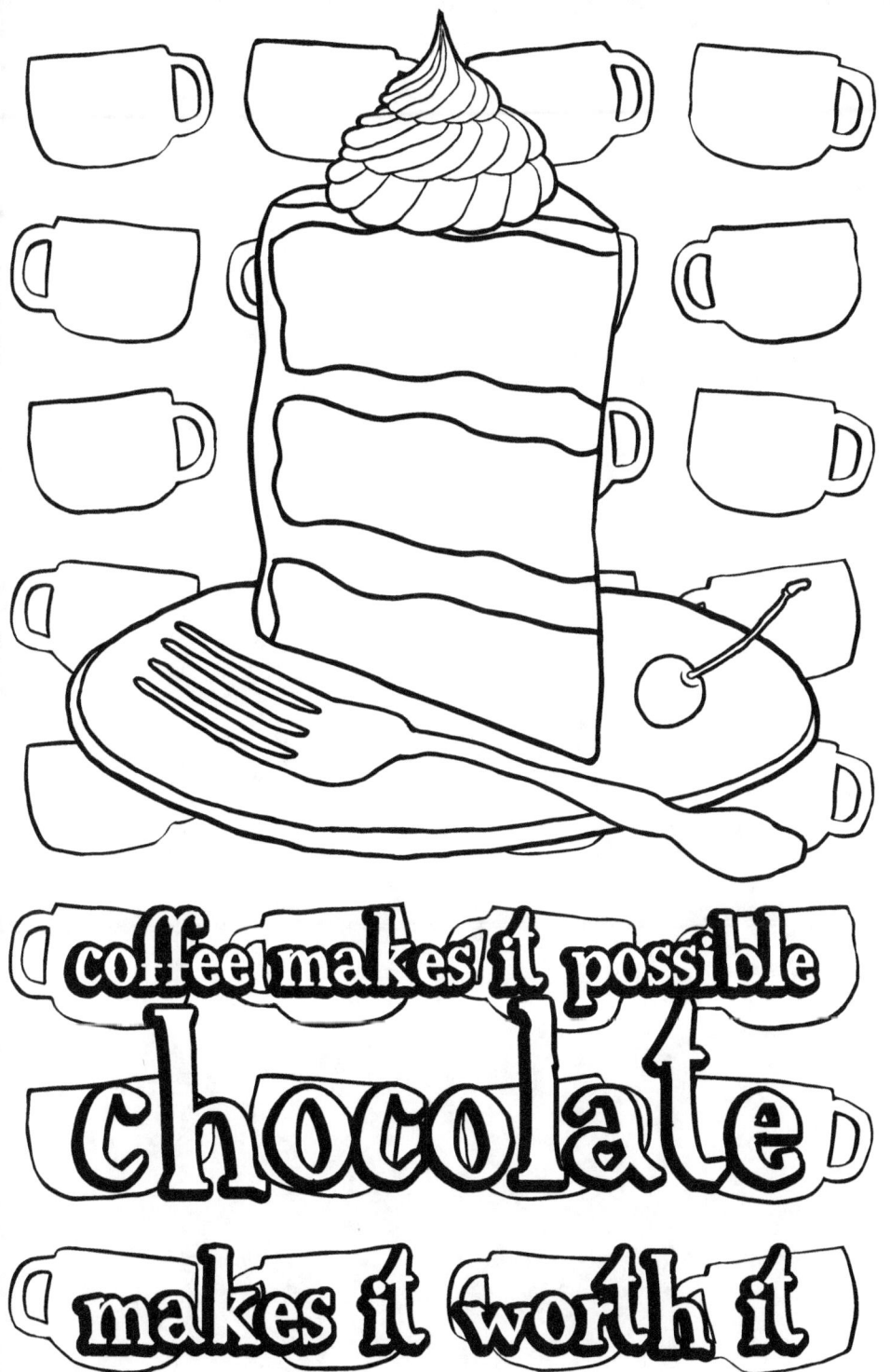

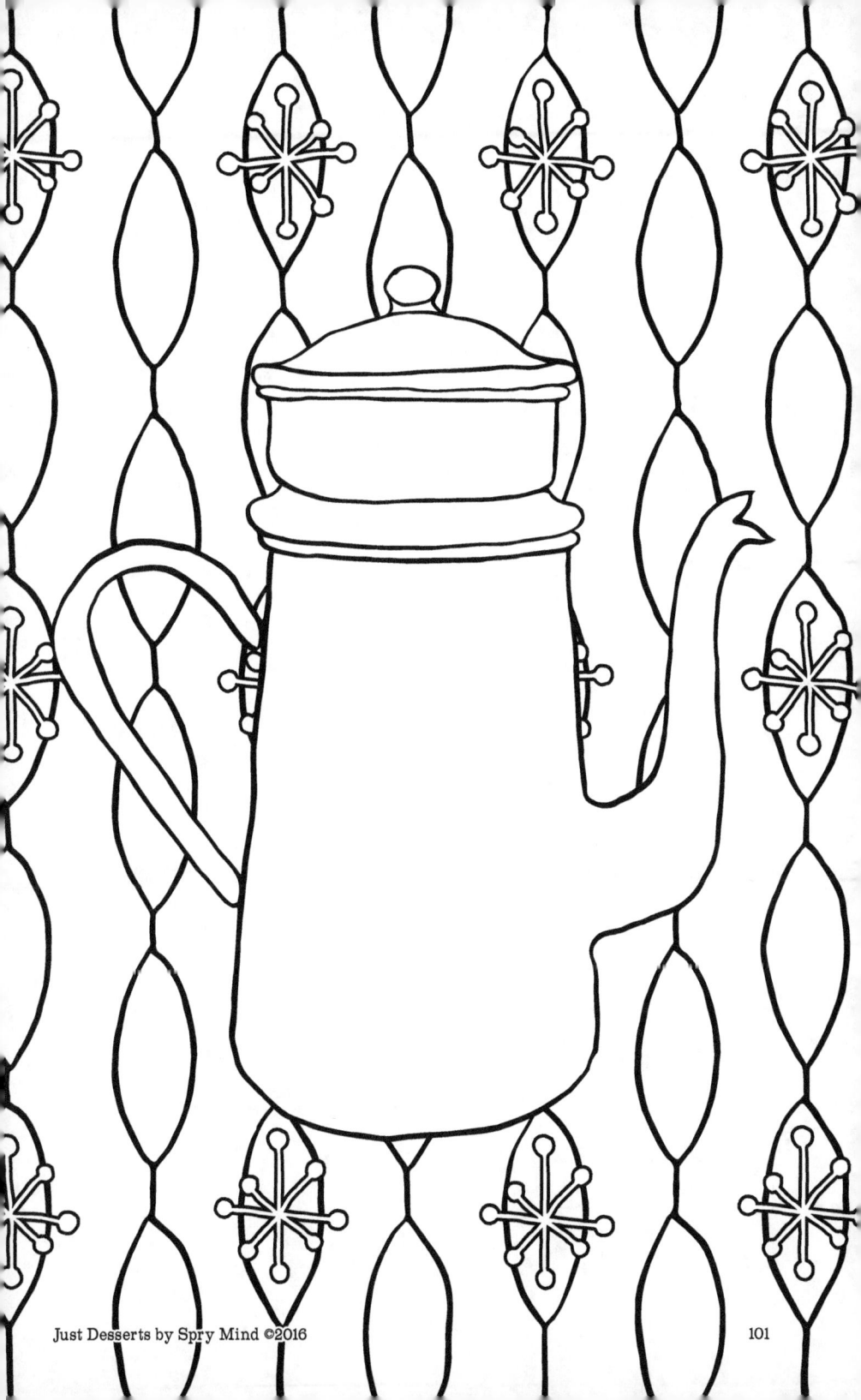

Bonus Pages!

My book "American Pride" contains some old-fashioned American desserts. I've included them here for you for free.

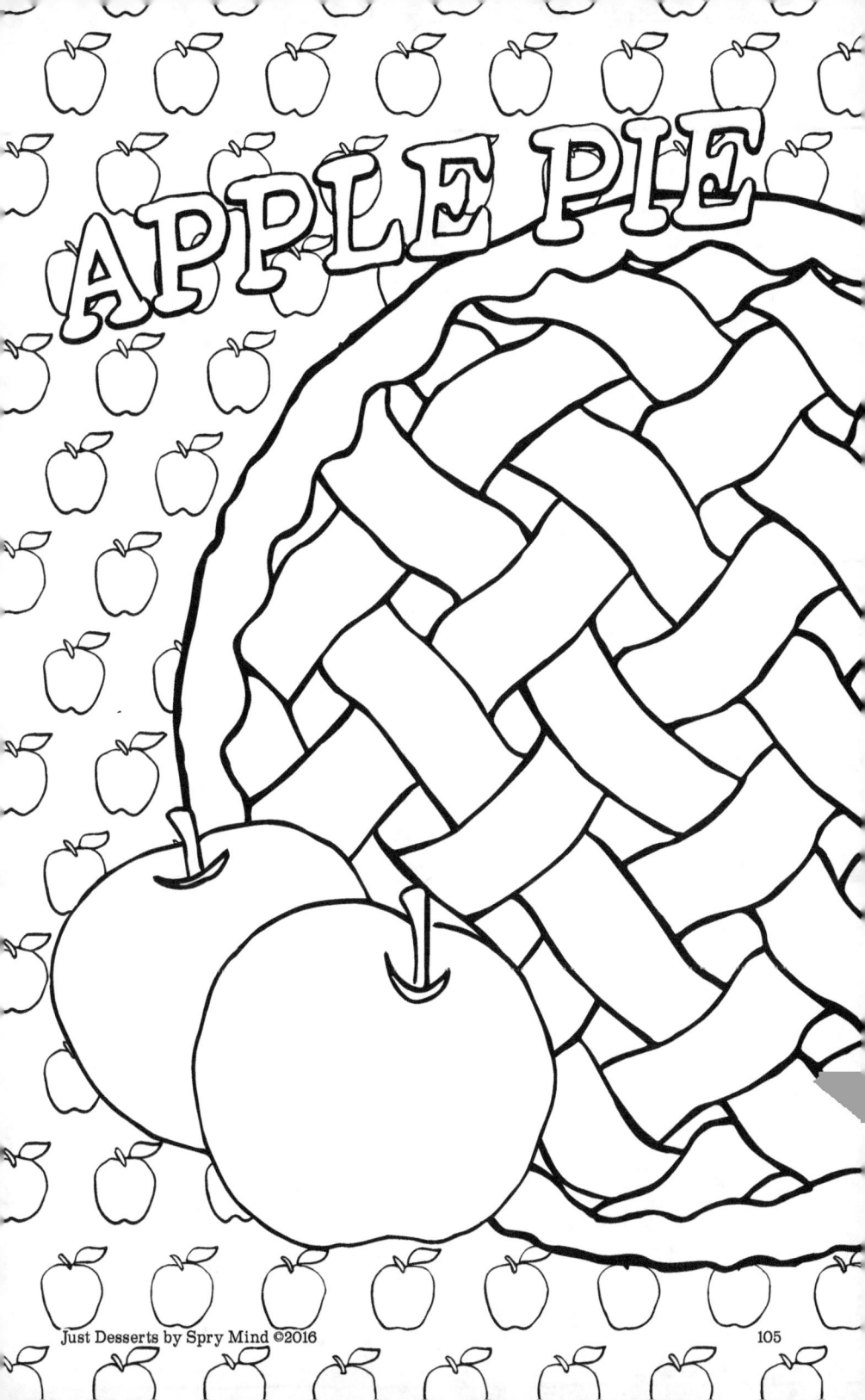

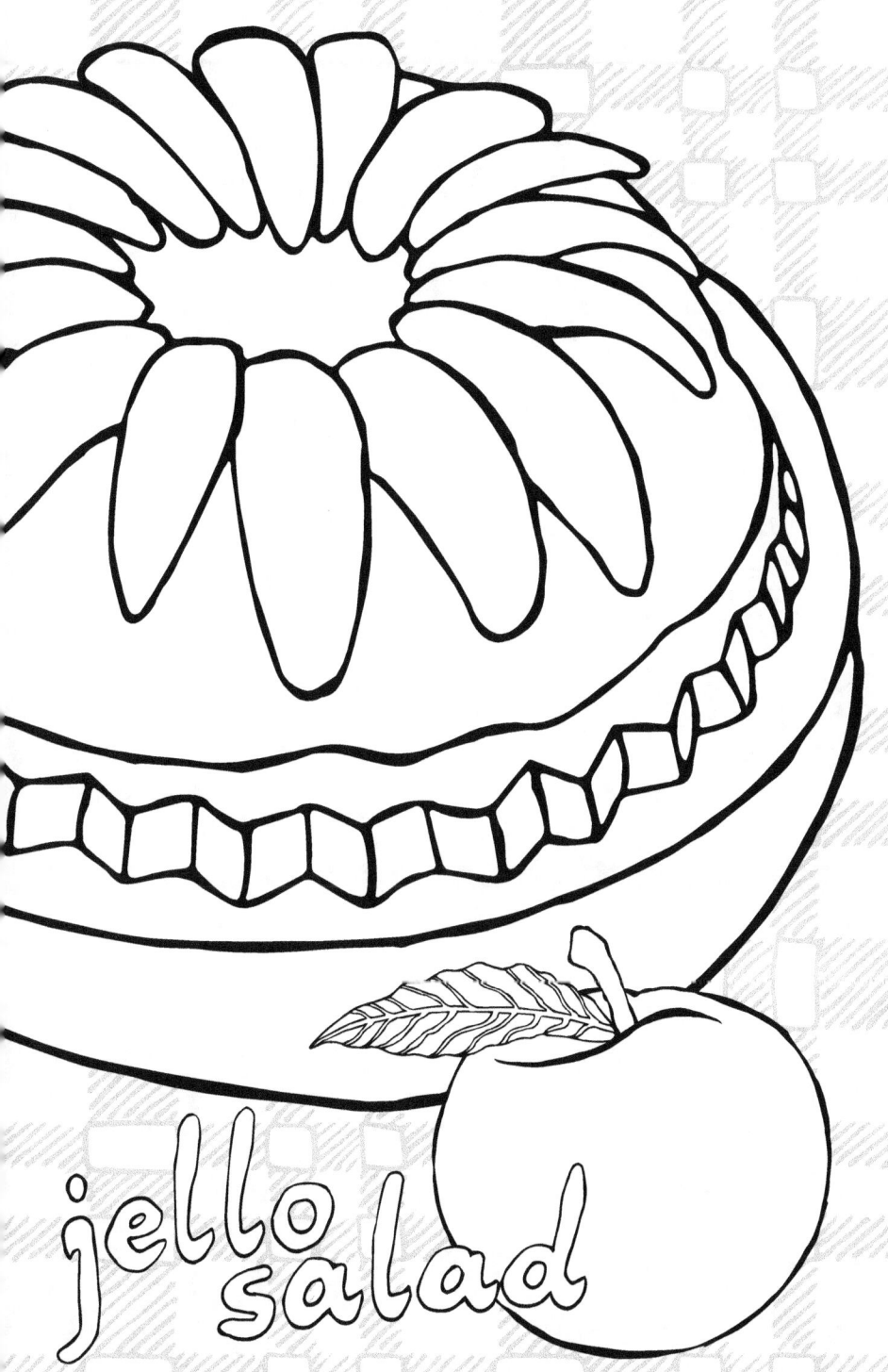

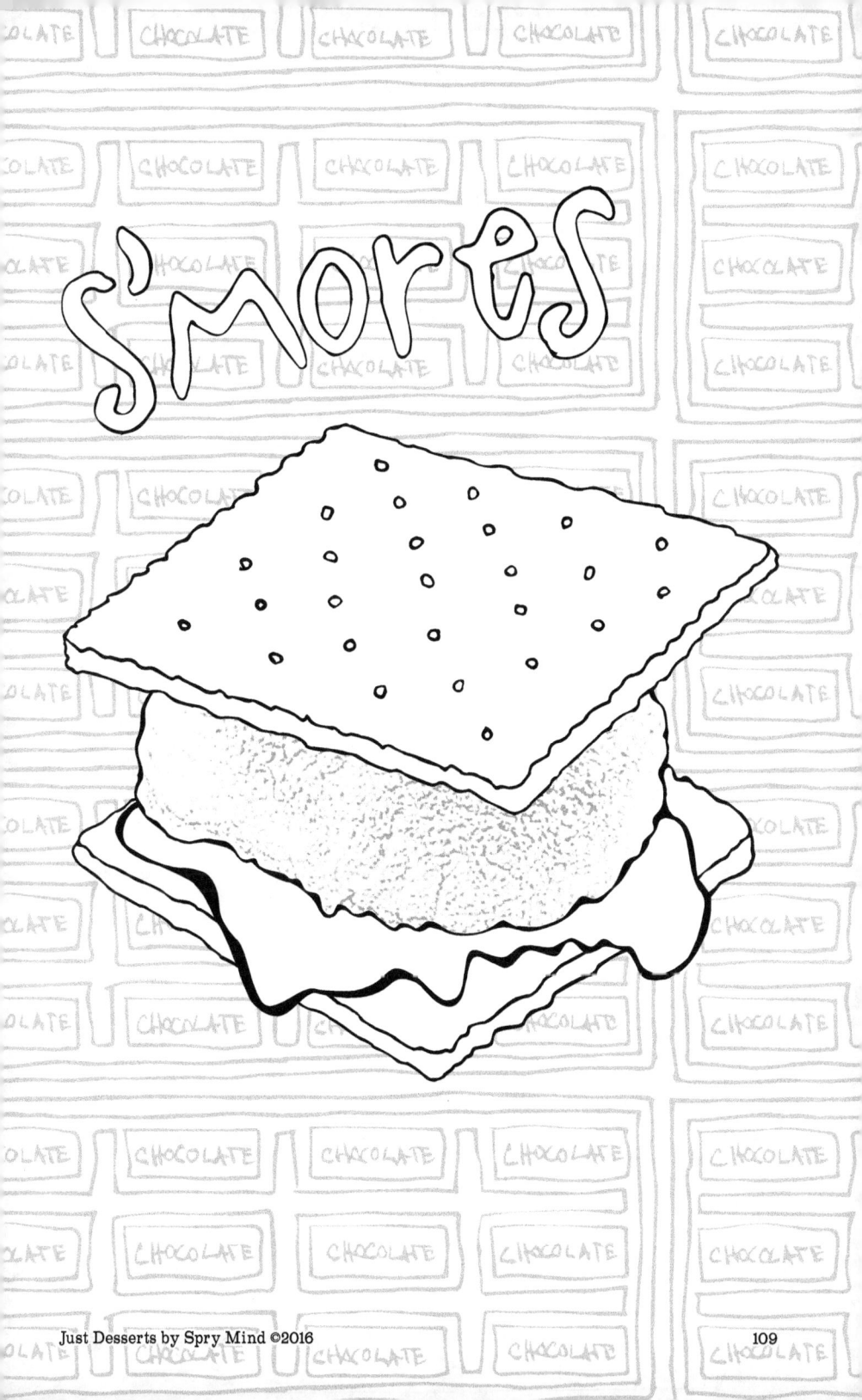

Other Spry Mind Titles

Check out these other titles from Spry Mind.

www.ingramcontent.com/pod-product-compliance
Lightning Source LLC
Chambersburg PA
CBHW060350190526
45169CB00002B/559